HOBSON'S CHOICE

Harold Brighouse

HOBSON'S CHOICE

in a new adaptation by
Tanika Gupta

OBERON BOOKS
LONDON

First published in this adaptation in 2003 by Oberon Books Ltd.
(incorporating Absolute Classics)
521 Caledonian Road, London N7 9RH
Tel: 020 7607 3637 / Fax: 020 7607 3629

e-mail: oberon.books@btinternet.com
www.oberonbooks.com

A catalogue record for this book is available from the British
Library.

ISBN: 1 84002 383 X

Printed in Great Britain by Antony Rowe Ltd, Chippenham.

Contents

Preface

It was David Lan who suggested that I write an 'Asian version' of *Hobson's Choice*. I leapt at the chance, having always loved the play and having seen so many resonances in the story with the dynamics of first- and second-generation immigrant family life. Keeping the comedy alive and the play still firmly planted in Salford I moved it to a contemporary setting.

Hobson and his daughters slipped with ease into a Bengali-Hindu background living in a multi-cultural society. Henry Horatio Hobson was thus transformed into the Asian patriarch Hari Hobson, who adopted the name of the shop he bought in Salford, in 1967. He held onto firm beliefs on caste, religion, social status and the (subservient) status of women whilst at the same time seeking to assimilate.

Perhaps the boldest decision I took was to transpose the play's setting from a cobbler's shop to a tailor's (inspired in part by the fact that Brighouse himself came from a textile family). Even today, Asians of all classes still prefer to have their outfits tailored and there is a rather uncomfortable dichotomy between the modern glamorous Asian catwalk fashion industry and the behind-the-scenes reality of sweatshop labour. Will Mossop's oppressed working class cobbler of 1880 easily resonates with Ali Mossop's downtrodden tailor of 2003. After all, sweatshop labourers are not only found in Indonesia and Malaysia but here in the UK too.

The historical irony of Mahatma Gandhi's pronouncements on the cotton industry both in Lancashire and India didn't escape me either. While cotton was grown and spun in the Indus Valley for over 2000 years before it was taken up by the Western world, colonised India was not allowed to manufacture clothes. The British were only concerned with protecting the jobs of the textile mill workers of northwest England. Gandhi's profound act of resistance, wearing his characteristic homespun cloth, was to urge Indians to produce their own clothes with

spinning wheels rather than become consumers of imported manufactured clothing. In 1922, urging working class mill workers in England to join Indians in solidarity against the British government, he wrote: 'India cannot live for Lancashire before she is able to live for herself.'

Hari Hobson may well have ended up a long way from his birthplace but Brighouse's textile business and the modern rag trade in Salford and Manchester owe a lot to India.

On turning to the play with the thought of adapting it, I was most struck by the power, vibrancy and dry wit of Maggie Hobson (now Durga). Conceived at a time when the Suffragettes were campaigning for votes for women, she comes across now as a modern feminist. She stands up for herself, turns the tables on her domineering father and secures her future, even finding love along the way. Her quick thinking is admirable and the scenes between her and her father provide some of the funniest and most emotional scenes of the play.

Always anxious to dismiss stereotypes I took the opportunity to portray Durga as a feisty, clever and ambitious Asian woman – not an old maid but a canny businesswoman. Hari Hobson has the conservative aspirations of a typical immigrant tied to old fashioned ideals – but Durga, her sisters and Ali Mossop are the second generation who seek to break the mould and define a new identity. Hence their clash is specifically Asian but, more generally, inter-generational. After all, families are universally peculiar, oppressive, supportive, awful and loving – whatever their cultural baggage. The Hobson family are no different.

Finally, for me the most life-affirming element of *Hobson's Choice* is the journey of Ali Mossop. He displays the inherent potential of all human beings to transcend their origins, condition and position in society. It only takes a shove in the right direction from Durga for him to blossom into a man. As Durga teaches Ali to read on their wedding night – the sweetness of the sentiments expressed in these simple lines are both funny and relevant:

DURGA: (*Reading.*) 'There is always room at the top.' Your writing's improving. Ali – I'll set you a short exercise for tonight... (*Writing.*) 'Great things grow from small.' Now then, you can sit down here and copy that.

<div align="right">

Tanika Gupta
June 2003

</div>

Characters

DURGA HOBSON*
eldest daughter of Hobson

SUNITA HOBSON
middle daughter of Hobson

RUBY HOBSON
youngest daughter of Hobson

HARI HOBSON
owner of Hobson's tailor's shop

ALI MOSSOP
tailor in Hobson's shop

TUBBY MOHAMMED
tailor/foreman in Hobson's shop

STEVE PROSSER
solicitor, Sunita's partner

JIM HEELER
Hobson's drinking partner

DR BANNERJI
doctor and rich customer

PINKY KHAN
Ali Mossop's girlfriend

ROBBIE ASH
photographer, Ruby's partner

* Durga is the ten-armed goddess who was sent by the gods to do battle with evil. In each hand she carries a different weapon. In one aspect she is Kali – goddess of death and destruction. In her more Aryan form of Durga she is maternal, wife of the god Shiva, mother of Ganesha (god of wealth), Kartik (god of valour), Saraswati (goddess of learning), Laxmi (goddess of well being).

This adaptation of *Hobson's Choice* was first performed at the Young Vic Theatre on 26 June 2003, with the following cast:

DURGA, Yasmin Wilde
SUNITA, Vineeta Rishi
RUBY, Paven Virk
HOBSON, Paul Bhattacharjee
ALI, Richard Sumitro
TUBBY, Agron Biba
STEVE, Gareth Farr
JIM, Martin Walsh
DR BANNERJI, Shelley King
PINKY, Zenab Khan
ROBBIE, James Kristian

Director, Richard Jones
Designer, Ultz

ACT ONE

We are inside HOBSON's tailor's shop in Chapel Street, Salford.
We see an array of women's saris and salwaar kamizes on display.
They range from functional, modern styles and sari blouses to silk
evening wear, bridal wear and intricately embroidered shawls. There
are also some men's suits on a rail but these are ready made, Armani
lookalikes. The shop is shabby and run down and has not been very
recently modernised. A large antique mirror stands to one side and
there are a couple of changing cubicles with curtains that can be
drawn for privacy. A large statue to the elephant god Ganesha sits*
in splendour on the counter by the till.

As the lights go up, we hear the sound of sewing machines whirring
from a back room.

Justin Timberlake/Sugababes/Punjabi MC blares out on the radio
as SUNITA and RUBY practice a dance routine in the shop. They
are dressed in old-fashioned salwaar kamizes looking every bit the
good Indian girl but dancing like stars on MTV.

DURGA enters. SUNITA and RUBY jump up and switch off the
radio. DURGA gives them both a look.

All three girls have strong Salford accents.

SUNITA: Oh, it's you. I was hoping it was Baba on his way
out.

DURGA: It isn't.

SUNITA: He is late this morning.

DURGA: He got up late.

> *DURGA busies herself with a spreadsheet on the computer*
> *screen.*

RUBY: Has he had breakfast yet Durga?

* 'Elephant God' – god of wealth.

13

DURGA: Breakfast! What? With a meeting of the Salford Asian Small Businesses Association last night?

SUNITA: Dunno why the call 'em 'meetings' – more like piss-ups.

RUBY: He'll need reviving.

SUNITA: Then I wish he'd get on with it.

RUBY: Sunita – expecting someone are you?

SUNITA: You know I am. And I'd be very grateful if you'd both leave us alone when he comes.

RUBY: I don't mind, as long as Baba's gone out first. You know I can't leave the counter while he's around.

STEVE PROSSER enters from the street. He is an English man in his mid-twenties, wearing a suit. He looks like a smart solicitor. He crosses the shop and smiles flirtatiously at SUNITA.

STEVE: Alright Suni?

SUNITA: Morning. (*She leans across the counter.*) Baba's still here.

STEVE looks worried. He turns to go.

STEVE: Oh!

DURGA: (*Rising.*) What can we do for you?

STEVE: I didn't really come to buy anything…Miss Hobson.

DURGA: This is a shop you know. I can't let you go without buying something.

STEVE: Alright – I'll just have a tie then. A plain one'll do, nothing flash…

He idly picks out a tie from the tie rack.

DURGA looks at STEVE thoughtfully.

DURGA: Let me see…I'd say chest forty inch, collar size sixteen…

STEVE looks self-conscious. DURGA whips out a tape measure and measures STEVE's chest. He looks helplessly over at SUNITA.

Yes…as I thought…forty… Now – Inside leg…

DURGA hands over the tape measure to STEVE who holds it – bemused.

Come on.

STEVE places the end of the tape measure self-consciously at the top of his leg.

DURGA bends down at his feet and reads out the measurement.

Thirty-two and a half.

STEVE: Does it matter to the tie?

DURGA: It matters to the suit. (*She measures the length of his jacket and his waist.*)

STEVE: But…

DURGA: (*To RUBY.*) Bring me one of them suits that came in from last week's shipment – Steve's size. (*To STEVE.*) We import them 'specially from exclusive tailors in Bangalore – MG Road no less. It's time you had a new shirt as well. The cuffs on these are beginning to wear. A disgraceful state! And you're supposed to be a professional man?

DURGA helps STEVE out of his jacket.

SUNITA: Durga! Steve didn't come here to buy a shirt or a suit.

RUBY comes down to DURGA with a suit.

DURGA: I wonder what does bring him here so often?

STEVE: I'm not much good wi' ties. Keep losing 'em.

DURGA helps STEVE into the new jacket.

DURGA: Do you lose one a day?

STEVE: Eh?

DURGA: You're in here seven days a week.

STEVE: It's as good to be prepared.

DURGA: And now you'll have a suit to go with the tie. How does that feel?

STEVE admires himself in the new jacket in the mirror.

STEVE: Very comfortable.

DURGA: Would you like to try on the trousers?

STEVE: Oh no. I really don't want to buy…

DURGA: (*Pushing him towards the fitting room.*) Try the trousers on. You can't go through the streets in just a jacket.

STEVE disappears into the fitting room.

DURGA pulls the curtain for privacy.

STEVE: (*From behind the screen.*) What's the damage on this?

DURGA: One hundred and fifty pounds.

STEVE: You what?

DURGA: It's worth every penny. Just look at the cut! People'll think you're wearing Armani. A smartly dressed solicitor inspires confidence. You'll have all your lady clients drooling over you and you don't need to buy a tie today because I'll throw it in as a discount.

STEVE emerges from the fitting room wearing the new suit.

STEVE: I really don't want to…

DURGA: What did I tell you? A perfect fit – very sexy – what d'you think Suni?

SUNITA looks embarrassed but STEVE is easily flattered.

DURGA puts out her hand.

STEVE looks at himself in the mirror. He can't deny it – the suit fits like a glove. He reluctantly takes out a credit card which she hands to SUNITA.

SUNITA swipes the card and takes the payment.

You might as well wear your new suit to work. I'll pack up your old one.

DURGA throws STEVE'S old suit at RUBY who gives a little scream at the interruption of her reading.

STEVE gasps.

STEVE: Well, if anyone had told me I was coming in here to spend a hundred and fifty pounds, I'd have called 'em mad.

STEVE signs the docket for his credit card.

SUNITA hands him back his credit card. She looks apologetic.

DURGA: You show me a shop, here in Salford that can sell you a better cut suit and I'll refund you. Good morning Mr Prosser.

DURGA holds the door open for STEVE.

He looks blankly at SUNITA and exits.

SUNITA: Talk about sharp business practices!

DURGA: It'll teach him to keep out of here a bit.

SUNITA: You know why he comes.

DURGA: I know he's always hanging around here; he should pay us rent, buying a tie every day's not nearly enough; behaving like a wet rag around you. He gets on me nerves.

SUNITA: Just 'cos you're past it. If Baba won't let us go out, where else can Steve meet me?

DURGA: If he wants to marry you why doesn't he?

SUNITA: You can't get married just like that. You're supposed to go out with a lad. Dating's got to come first.

DURGA: It needn't.

She points at a particularly ornately sequined piece of cloth.

See that shawl with all those sequins to make it pretty? Dating's like that. All glitter and no use to anybody.

HOBSON enters from the back of the house. He is a fifty-five year old Asian man, successful, coarse and a little flushed from the booze. His accent is Indian with a hint of Salford.

HOBSON: Durga. I'm just popping out for a quarter of an hour.

DURGA: Okay. Don't be late for lunch.

HOBSON: It's an hour 'til lunch time.

DURGA: If you're more than an hour in The Nelson you'll be late for it.

HOBSON: The Nelson? Who said? (*Turning.*)

RUBY: If your lunch's ruined, it'll be your own fault.

HOBSON: How dare you! Bloody nagging witches…

SUNITA: Don't swear Baba.

HOBSON: No I'll sit down instead.

He sits down.

Listen to me you three. I know what you're up to and I won't have it. You listening? Interfering busybodies. Always making sly remarks every time I go out. My patience is running thin.

DURGA: Jim's probably waiting for you in pub.

HOBSON: He can go on waiting. Right now, I'm addressing a few remarks to the rebellious females of this house and I'd be grateful for a little attention here. I've noticed it coming on ever since your mother died. There's been a gradual lack of respect towards me.

RUBY: You'd have more time to talk after we've closed tonight. (*She is anxious to get on with her reading.*)

HOBSON: I'm talking now and you're listening. Unfortunately the Good Lord saw it fit to take away your mother just at the moment you lot need controlling. But I'll tell you this, I'm the boss and you'll live by my rules. I want more respect and less arrogant behaviour.

SUNITA: I'm not arrogant.

HOBSON: Yes you are. You're pretty but you're arrogant and I hate arrogance like I hate a lawyer.

RUBY: If we take trouble to feed you it's not arrogant to ask you not to be late for your food.

SUNITA: Give and take.

HOBSON: I give and you take, and it's going to end.

DURGA: How much a week do you give us?

HOBSON: That's neither here nor there. (*Rises and moves to the door.*) You'd better change your attitude towards me.

No more cheek. But that's not all. That's private conduct and now I pass to broader aspects and I speak of public conduct. I saw my girls walking around last week and I was appalled. You've dishonoured the Hobson family name.

SUNITA: What're you on about?

HOBSON: As if you didn't know. You're very pretty, but you can lie like a gasmeter. Who was wearing skirts last week?

RUBY: I suppose you mean Sunita and me?

HOBSON: I do.

SUNITA: We can dress how we want and anyway you like to see me in nice clothes.

HOBSON: Yes – That's why I pay Tubby bhai extra to dress you proper, in silks and crèpe de chine. It pleases the eye and it's good for business. But if you could've seen the state of yourselves, you'd be ashamed. I saw you and Ruby out of The Nelson bar on Thursday night and my friend Sam Minns –

RUBY: A man who works the bar…

HOBSON: As honest a man as Lord Ganesha ever set behind a bar, young ladies. My friend, Sam Minns, asked me who you were. And I'm not surprised. You were walking down Chapel Street flashing your bare legs at everyone.

SUNITA: Baba!

HOBSON: It's outrageous!

RUBY: It's not outrageous. It's cool.

HOBSON: Bugger cool.

DURGA: You're not in The Nelson now.

SUNITA: You should see what women are wearing these days.

HOBSON: If what I saw on you is any guide, I won't bother. I'm a decent minded man. I'm Hobson. I'm British middle-class and proud of it. I stand for common sense and sincerity. When I first came to this country – thirty-five years ago – I took the name of this shop in good faith. Made it my own. There's integrity for you. I'm not like all those phoney asylum seekers scrounging off the state – always whingeing. I've worked hard in this country all my life. You forget the majesty of trade and the unparalleled virtues of the British constitution, which are all based on the sanity of the middle classes combined with the diligence of the working classes. You, my girls, are losing balance. You don't seem to understand your place in life.

SUNITA: Which is?

HOBSON: It's a man's world and you girls should keep within your boundaries and do as you're told.

RUBY: We shall continue to dress as we like.

HOBSON: Then I've no choice for you two. If you want to go on living under my roof, eating the food I put on the table, wearing the clothes I put on your backs, you'd better change your ways. Or else.

RUBY: Or else what?

HOBSON: I'll arrange a marriage for you two, my girls. That's what I'll do.

RUBY: Can't we choose our own husbands?

HOBSON: I've been telling you for the last five minutes you're not even fit to choose dresses for yourselves.

DURGA: You're talking a lot to Sunita and Ruby. What about me?

HOBSON: You? (*Turning astonished.*)

DURGA: If you're doling out husbands, don't I get one?

HOBSON: (*Laughs.*) Well, that's a good one. You with a
husband?

DURGA: Why not?

HOBSON: I thought you'd sense enough to know. But if
you want the honest truth, you're a confirmed spinster.

DURGA: I'm thirty.

HOBSON: Aye, thirty, on the shelf and past your sell by
date. But you two, now, I've told you. I'll have less cheek
from you or else I'll shove you off my hands on to some
other men. You can just choose which way you like.

HOBSON heads for the door.

DURGA: One o'clock lunch.

HOBSON: Listen Durga. I set the rules in this house. It's
One o'clock lunch because I say it is and not because
you do.

DURGA: Yes.

HOBSON heads towards the door.

HOBSON: So long as that's clear I'll go.

HOBSON hesitates as he sees a woman approaching the shop.

Better not, Dr Bannerji's here…

*DR BANNERJI, a smartly dressed woman in a modern
salwaar kamiz enters. She has a curt manner and a Scottish
accent which gets more pronounced when she gets agitated.*

Good morning Dr Bannerji. What a lovely day!

HOBSON places a chair for her.

DR BANNERJI: (*Sitting.*) Morning. I've come about this suit I had made up last week.

DR BANNERJI gestures to the suit she's wearing.

HOBSON looks her up and down rather stupidly. He kneels on the floor to check the trouser length is right and fondles the hem.

HOBSON: Seems to fit perfectly doctor.

DR BANNERJI: Get up Hari. You look ridiculous on the floor. Who made this suit?

HOBSON scrambles up.

HOBSON: We did. It's our own make.

DR BANNERJI: Will you answer a simple question? Who made this suit?

HOBSON: It was made on the premises.

DR BANNERJI turns to DURGA.

DR BANNERJI: Durga, you seemed to have some sense when you served me. Can you answer me?

DURGA: I think so, but I'll make sure for you, Doctor.

DURGA calls down towards the basement.

Tubby bhai!

HOBSON: You wish to see the identical tailor Doctor?

DR BANNERJI: As I said.

HOBSON: I am responsible for all the work here.

DR BANNERJI: I never said you weren't.

TUBBY emerges from the trap door in the floor. He is a white-haired old Asian man in shabby clothes with a large

belly. He has his white beard in a Muslim goatee. He looks at DURGA and stands half in the room, not coming right in.

TUBBY: (*Indian accent.*) Memsahib? (*He stands half-way up, not coming right up.*).

DR BANNERJI rises and approaches him.

DR BANNERJI: Tubby bhai* – Did you make this suit?

TUBBY looks at the doctor.

TUBBY: No Memsahib.

DR BANNERJI: Then who did? Do I have to question every soul in the place before I find out?

TUBBY: That's Ali's work.

DR BANNERJI: Then tell Ali, I want to see him.

TUBBY: Certainly Memsahib.

DR BANNERJI: Who's Ali?

HOBSON: Name of Mossop, Madam.

DR BANNERJI: Rather a strange name.

HOBSON: Ali's half and half I'm afraid – a child of the 'love generation'. His father was one of 'em hippies – abandoned his mother I believe. But if there's anything wrong I assure you I am capable of making the man suffer for it. I'll…

ALI MOSSOP emerges from the trap. He is mixed race, Asian and is dressed in even shabbier clothes than TUBBY. He is painfully shy and lacking in confidence. He wears a long tape measure round his neck and has tailor's chalk marks on his overalls. He too also stands half-way up the trap.

DR BANNERJI: Are you Mossop?

ALI: (*Indian accent.*) Yes Doctor.

* 'Brother' – a term of respect.

DR BANNERJI: You made this suit?

ALI peers at the doctor in her suit.

ALI: I made that last week.

DR BANNERJI: Take that.

ALI bending down rather expects 'that' to be a blow. Then he raises his head and finds that DR BANNERJI is holding out a visiting card. He takes it.

See what's on it?

ALI bends down over the card.

ALI: English?

DR BANNERJI: Read it.

ALI: I'm trying.

ALI's lips move as he tries to spell it out.

DR BANNERJI: Bless the man, can't you read English?

ALI: I do a bit. Only, it's such funny print.

DR BANNERJI: It's the usual italics of a visiting card, ma' man. Now listen to me. I heard about this shop and what I heard brought me here for my clothes. I'm particular about what I put on my body.

HOBSON: I assure you, it shall not occur again Doctor.

DR BANNERJI: What shan't?

HOBSON: I – I don't know.

DR BANNERJI: Then be quiet. Mossop, I've tried every clothes shop in Manchester and this is the best-cut suit I've ever had. Now you'll make my clothes in future. You hear that, Hari?

HOBSON: Yes Doctor, of course …

DR BANNERJI: You'll keep that card, Ali, and don't you dare leave here and go to another tailor's shop without letting me know where you are.

HOBSON: He won't be leaving…

DR BANNERJI: How do you know? The man's a treasure and I bet you underpay him.

HOBSON: That'll do Ali. You can go.

ALI: Yes sir.

ALI bows and then ducks down into the basement quickly.

DR BANNERJI: He's like a rabbit.

DURGA: Can I take an order for another suit Doctor? Or perhaps an evening dress?

DR BANNERJI: Not yet but I shall send all five of my daughters here. And mind you, that man's to make their wedding outfits.

DURGA: Certainly doctor.

HOBSON opens the door.

DR BANNERJI: Goodbye.

HOBSON does a namaste.

HOBSON: Goodbye Doctor Bannerji. Very glad to have the honour of serving you, madam.

She goes out.

HOBSON closes the door.

I wish some people would mind their own business. What did she need to praise a tailor to his face for?

DURGA: Maybe he deserved it.

HOBSON: Rubbish! He'll get above himself. Last time she sets foot in my shop.

DURGA: Don't be silly.

HOBSON: I'll show her. Thinks she owns the earth because she lives in that flash house of hers? She's not coming in here again. I give you my word.

JIM HEELER enters.

JIM: (*To HOBSON.*) That were a bit of a shock.

HOBSON: Eh? Oh, morning Jim.

JIM: You must be doing a roaring trade.

HOBSON: What?

JIM: Wasn't that Dr Bannerji?

HOBSON: Oh…yes. She's an old and valued customer of mine.

JIM: And she's loaded. How come you never mentioned her before?

HOBSON: What's to mention? I've made clothes for her and all her circle for…how long Durga? Oh, I dunno.

JIM: In that case, the drinks are on you today.

HOBSON: It all goes back into stock and wages.

JIM: (*Laughs.*) Excuses, excuses…Come on then, let's go.

HOBSON hesitates.

Aren't you coming?

HOBSON: Yes, that is …no.

JIM: Are you ill?

HOBSON: No. Get away, you girls. I'll look after the shop. I want to talk to Jim.

JIM: Why can't we talk in The Nelson?

The girls all leave the room, DURGA last.

HOBSON: I need to talk.

JIM: What's wrong with doing it over a pint?

HOBSON: I don't want Sanjay, Dilip, Rohan and Sam all listening in.

JIM: Ah…so it's private. What's the trouble Hari?

HOBSON: Those bloody girls of mine – they're the trouble. Do your daughters give you a hard time Jim?

JIM: Nah – they mostly do as I bid them.

HOBSON: Ah Jim, a wife's a handy thing and you don't realise it properly till she's taken from you. I felt grateful for the quiet when my Shukla went but I can see she had her uses. She was hard work when she started on her nagging but I've realised something.

JIM: What's that?

HOBSON: The domination of one woman is paradise to the domination of three.

JIM: You've had a rough deal.

HOBSON: I'm a talkative man by nature Jim. You know that.

JIM: You're an orator Hari.

HOBSON: A good case needs no flattery.

JIM: Well, you're the best debater in The Nelson bar.

HOBSON: True, true. In the estimation of my fellow men, my words have weight. In the eyes of my daughters, I'm a bore – a windbag.

JIM: No, never!

HOBSON: I am. They mock my wisdom. They answer me back. My own daughters have got the upper hand of me.

JIM: They want a firm hand.

HOBSON: I've lifted up my voice and roared at them.

JIM: Shouting doesn't help. You need to keep calm, show them who's boss through your demeanour. A dignified silence and the odd sharp word keeps the women under control.

HOBSON: I've tried all ways and I'm at my wit's end. I don't know what to do.

JIM: Easiest thing to do would be to get them married off.

HOBSON: I've thought of that. Trouble is to find the men.

JIM: Shouldn't be a problem. What sort of husbands do you want?

HOBSON: Sober young men with no vices.

JIM: Now come on – be realistic. You've got three daughters to find husbands for.

HOBSON: Two Jim, two.

JIM: Two?

HOBSON: Sunita and Ruby are mostly window dressing in the shop. But Durga's too useful to get rid of. And she's a bit on the ripe side for marrying.

JIM: She's not that old. I've seen 'em do it at double her age – but leaving her out, you've got two.

HOBSON: One'll do for a start. It's something I've noticed about women. Have one wedding in a family and it goes through the lot like chicken pox.

JIM: Sober young men you say? Hmmm... It'll cost you a bit you know.

HOBSON: Eh? Oh, I'm willing to flash some cash.

JIM: In your culture you have to pay for the furniture.

HOBSON looks bemused.

HOBSON: I'll pay for the weddings.

JIM: It's not the way it's done though is it? There's gifts for the in-laws: a new suit for the groom, a fridge for the mother in law and a hundred saris for the women. 'Course you mustn't forget the astrologer.

HOBSON: What would I be wanting with an astrologer?

JIM: You gotta do things properly. Don't want to upset tradition – you being such a leader of the community and all that.

HOBSON still looks bemused.

Got to choose the right day for the wedding – when the stars are auspicious. You know that. Then there's the priest Hari. They don't come cheap. They'll be wanting pure Ganges water all the way from India for the ceremony and you'll probably have to inform the local fire services – give 'em a back hander to keep 'em quiet. They get very jumpy about Hindu weddings, what with those fires the bride and groom've got to walk around – seven rounds for seven lifetimes. Now there's a thing eh? Married for seven lifetimes! Oh and then there's the gold for the bride and her special wedding bangles – the ones made out of iron…

HOBSON: Enough!

JIM: You'll have to bait your hook to catch fish.

HOBSON: Then I won't go fishing.

JIM: But you said –

HOBSON: I've changed my mind. I wanted a bit of peace, but this is going too far.

JIM: But I was looking forward to the wedding! According to your customs, dads can never give away their daughters – whereas the uncles can so I was hoping to step in there like. I know of a good Asian family with a son – in Oldham – just right for Sunita. Steady job, bad skin but a nice lad…

HOBSON: Forget it.

JIM: You'll save their keep.

HOBSON: They work for that and they don't eat much.

JIM: And their wages.

HOBSON: Do you think I pay wages to my own daughters? I'm not a fool.

JIM: Then it's all off?

HOBSON: Dead off. Let's go to The Nelson.

HOBSON gets up.

JIM remains seated, puzzled by his friend's change of heart.

You coming for a drink or not? (*Calls out.*) Shop! Shop!

JIM gets up.

I'm going out Durga.

DURGA remains by the door to the dining area.

DURGA: Lunch is at one, remember.

HOBSON: Lunch will be when I come in for it. I'm the boss here.

DURGA: Yes Baba. One o'clock.

HOBSON: Come along Jim.

HOBSON and JIM exit.

DURGA lifts the trap door and calls out.

DURGA: Ali. Come here.

ALI MOSSOP appears and stops half-way up the trap.

ALI: Memsahib?

DURGA: Come up and put the trap down. I need a word with you.

ALI comes up – reluctantly.

ALI: We're very busy in the basement.

DURGA points to the trap.

He closes it.

DURGA: Show me your hands.

ALI holds his hands out hesitatingly.

Clever hands. They can shape cloth like no other man that ever came into the business. Who taught you Ali?

She retains his hands.

ALI: My uncle – in Kolkatta. He was a tailor.

DURGA: I didn't think it were me Baba. He doesn't know how to sew and cut. You're a natural at making clothes. It's a pity you're a natural fool as well.

ALI: I'm not much good at anything but sewing and that's a fact.

DURGA: When are you going to leave here?

ALI: Leave here?

DURGA: Don't you want to go?

ALI: Yes but… I've been at Hobson's since I first came to this country.

DURGA: Don't you want to get on? You heard what Doctor Bannerji said. You know the wages you get and you know the wages a tailor like you could get in one of the exclusive shops in Manchester. Artisans like you are a dying breed.

ALI: I couldn't go.

DURGA: What keeps you here? Is it the – the people?

ALI: Your Baba. He's the one that got me the work permit.

DURGA: I see.

ALI: And he's got my passport.

DURGA: And threatened to report you to the immigration authorities if you leave here?

ALI remains silent.

Do you know what keeps this business going? Two things: one's good cut clothes you make that sell themselves, the other's bad clothes the big manufacturers make and I sell. We're a pair, Ali Mossop.

ALI: You're a wonder in the shop Memsahib.

DURGA: And you're a wizard in the workshop. So?

ALI: So…what?

DURGA: It's obvious.

ALI: What is?

DURGA: You're leaving me to do all the work.

ALI: I'd better get back to my work.

ALI moves towards the trap.

33

DURGA: (*Stopping him.*) I haven't finished with you. I've watched you for a long time and everything I've seen, I like. I think you'll do for me.

ALI looks anxious.

You're my man. I've been turning it over in my head for six months now. It's time for some action.

ALI: But I never –

DURGA: I know you never, or it wouldn't be left to me to do the asking. And please – stop calling me Memsahib. We're equals. My name is Durga.

ALI sits down in an armchair.

ALI: What d'you want me for?

DURGA: To invest in. You're a business idea in the shape of a man.

ALI: I've got no head for business at all.

DURGA: But I have. My brain and your hands'll make a working partnership.

ALI gets up relieved.

ALI: Partnership! Oh that's a different thing. I thought you were axing me to marry you.

DURGA: I am.

ALI: Heh – Allah! And you the Sahib's daughter.

DURGA: Maybe that's why Ali. Maybe I've had enough of Baba and you're as different from him as any man I know.

ALI: It's a bit difficult.

DURGA: What's difficult? We get married and as my husband you can stay here – permanently.

ALI: But…

DURGA: I'll tell you something Ali. I'd be a fool to stand by and let the best chance of my life slip through me fingers.

ALI: I'm your best chance?

DURGA: You are that.

ALI: Heh Allah! I never thought of that.

DURGA: Think of it now.

ALI: I am. But it's a bit of a shock…I can't think clear. I have much respect for you Memsahib Durga. You're brilliant at selling in the shop and you've got a shapely body but when it comes to marrying, well…I'm sorry but I'm not in love with you.

DURGA: Wait till you're asked. I want your hand in mine and your word that you'll go through life with me through thick and thin.

ALI: We won't get far without love.

DURGA: I've got the love alright.

ALI: You're very determined on this. What would your Baba say? And me a Musulman?

DURGA: He'll say a lot and he can say it. It'll make no difference to me.

ALI: Much better not to upset him. It's not worth it.

DURGA: Let me be the judge of that. You're going to marry me Ali.

ALI: I can't do that. I can see that I'm messing up your plans…

DURGA: When I make plans, I follow them through.

ALI: What makes it so difficult is that…I'm engaged.

DURGA: You're what?

ALI: Pinky Khan.

DURGA: Whose Pinky Khan?

ALI: I'm the lodger at her mother's.

DURGA: That dark skinned slag who brings your lunch?

ALI: Pinky's fair skinned. And she'll be here soon.

DURGA: And so shall I. I'll talk to Pinky. I've seen her and I know the type. She's the simpering, girly type.

ALI: She needs protecting.

DURGA: That's how she got you is it? Yes, I can see her clinging round your neck until you imagined you were Sharukh Khan. But I can tell you this, my lad, she must be bloody desperate looking for protection from you.

ALI: Pinky loves me.

DURGA: You marry her and you'll be broke all your life – slaving away for peanuts, trying to feed and clothe a tatty bunch of snot-nosed kids. You'll be a tailor on the minimum wage all your life exploited by Pinky on the one hand and the likes of my Baba on the other. Marry me and you'll be running your own business before long.

ALI: I'm not ambitious – I know that.

DURGA: No, but you're going to be. Oh God, have I got my work cut out…

ALI: I wish you'd leave me alone.

DURGA: So does the fly when the spider catches him. You're my man, Ali Mossop.

ALI: But…Pinky…

PINKY KHAN enters the shop. She is a meek-looking Asian girl dressed traditionally in synthetic fabrics. She brings in ALI's lunch in a tiffin carrier. PINKY crosses to ALI and gives him his lunch.

PINKY: (*Salford accent.*) There's your lunch Ali.

ALI: Thank you Pinky.

She turns to go and finds DURGA in her way.

DURGA: I want a word with you. You're treading on my foot.

PINKY looks stupidly at DURGA'S foot.

PINKY: Me?

DURGA: What's this about you and him?

PINKY: (*Gushing.*) Oh Miss 'Obson, it's good of you to take an interest in us.

ALI: Pinky, she…

DURGA: Shush you. This is for me and her to sort out. Take a good look at him Pinky.

PINKY: At Ali?

DURGA: (*Nodding.*) Not much for two women to have a scrap about is there?

PINKY: Maybe he's not much to look at, but you should hear him play.

DURGA: Are you a musician Ali?

ALI: I play the ektara*.

DURGA: That's what you see in him is it? A gawky chap that plays the ektara?

PINKY: I see the man I love.

* One-stringed instrument. Makes a twanging sound. Particularly used in Bangladesh folk singing.

DURGA: So do I.

PINKY: You!

ALI: That's what I've been trying to tell you, Pinky, and if you're not careful, she'll take me from you.

PINKY: Excuse me. You're too late. Me and Ali are engaged.

DURGA: That's what you think.

PINKY: And I think you should mind your own business. Ali Mossop's mine.

ALI: That's what I tried to tell her but she won't listen.

DURGA: How d'you plan to make a living together? If it's a better plan than mine, I'll wish you luck and you can have your man.

PINKY: He'll work and I'll keep house. Maybe I'll get meself a part time job but when we have kids, I'll stay at home. I want to be around when they're growing up.

DURGA: It's worse than I thought. Ali, you better marry me.

PINKY: (*Weakly.*) It's daylight robbery.

ALI: Aren't you going to put up a better fight for me than that Pinky?

DURGA: You take orders from me in this shop.

ALI: Looks like there's no escape.

PINKY: Wait 'till I get you home. Ammi'll* have a few words to say to you.

DURGA: Ah – so it's the tart's mother who set this up?

PINKY: She called me a tart!

* Muslim term for 'Mummy'.

ALI: Her mother is keen on me.

DURGA: Why don't you marry her then?

ALI: Don't be ridiculous.

DURGA: I haven't got a mother Ali.

ALI: You don't need one.

DURGA: Can I sell you a handkerchief, Miss Khan?

PINKY: No.

DURGA: Then you've no business here have you?

DURGA opens the door to the shop.

PINKY: Ali?

DURGA: Goodbye.

PINKY: Are you going to let her order me out?

ALI: It's her shop Pinky.

PINKY: Is that it?

ALI: Best to go before things get violent.

PINKY: I'll show her violent...

ALI stands between the two women.

ALI: Pinky – please...

PINKY: It's a very shabby way to treat me.

DURGA: When it comes to leaving, it's best to go quickly. No whimpering.

PINKY: I in't whimpering and I in't parting either. But he'll be bawling tonight when my Ammi gets hold of him.

DURGA: That'll do.

PINKY exits.

ALI: I'd really rather marry Pinky, if it's all the same to you.

DURGA: Why? Because of her 'Ammi'?

ALI: She's scary.

DURGA: You wimp.

ALI: Yes, but you don't know her. She'll shout at me when I go home tonight. Very rough woman – who knows what else she'll do.

DURGA: Then you won't go home tonight.

ALI: Not go!

DURGA: Give up your room there. When you've knocked off work tonight you'll go to Tubby bhai's and Tubby'll go round to Pinky's for your things.

ALI: And I don't have to go back there ever?

DURGA: No.

ALI smiles.

DURGA: And while Tubby bhai's there you can go round and see Registrar about our wedding.

ALI: Oh, but I haven't got used to that idea yet.

DURGA: You'll have three weeks to get used to it. A simple registry office affair – that way we don't have to worry about Priests or Mullahs. Now, kiss me Ali.

ALI: That's forcing things a bit. It's like saying I agree to everything, a kiss is.

DURGA: Yes.

ALI: And I don't agree yet. I'm –

DURGA: Come on.

RUBY and SUNITA enter from the house.

Get on with it.

ALI: Now? With them here?

DURGA: Yes.

Beat.

ALI: I couldn't.

ALI ducks back down through the trap door and slams the door shut behind him.

SUNITA: What's the matter with Ali?

DURGA: He's a bit upset because I've told him he's going to marry me. How's lunch getting on?

RUBY: Hold up, what did you say?

DURGA: You heard me.

SUNITA: You're going to marry Ali Mossop? Ali Mossop?

RUBY: You kept that quiet.

DURGA: I've only just proposed.

RUBY: How could you?!

SUNITA: What you do effects us. I don't want Ali Mossop for my brother-in-law.

DURGA: Why? What's wrong with him?

SUNITA: Let's see what Baba has to say. And what about me? What about Steve?

DURGA: You'll marry Steve when he's able and that'll be when he starts spending less on clothes and season tickets to watch Man U.

HOBSON enters from the street.

HOBSON: Where's my lunch?

DURGA: It'll be ready in ten minutes.

HOBSON: You said one o'clock.

DURGA: One for half-past. If you wash your hands it'll be ready as soon as you are.

RUBY: Have you heard the news about our Durga?

HOBSON: News? There is no news. It's the same old tale. Cheek, arrogance and disrespect.

DURGA: Don't lose your temper. You'll need to be calm when Ruby tells you the news.

HOBSON: What's Ruby been doing?

RUBY: Nothing. It's about Ali Mossop.

HOBSON: Ali?

SUNITA: What's your opinion of him?

HOBSON: A decent boy. I've got nothing against him.

SUNITA: Would you like him in the family?

HOBSON: Whose family?

RUBY: Yours.

DURGA: I'm going to marry Ali Mossop. That's what all the fuss is about.

HOBSON: What?!

DURGA: You thought I was past the marrying age. I'm not. That's it. That's the news.

HOBSON: Didn't you hear me say I'd do the choosing when it came to the question of husbands?

DURGA: You said I was too old to get a husband.

HOBSON: You are. You all are.

RUBY: Baba!

HOBSON: And if you're not, it makes no difference. I'll have no husbands here.

SUNITA: But you said –

HOBSON: I've changed my mind. I've learnt some things since then. Too much is expected of fathers these days. There'll be no weddings here.

SUNITA: Oh Baba!

HOBSON: Shut up and get my lunch served. Go on now. I'm not in the mood to hear your rantings.

HOBSON shoos SUNITA and RUBY away. They exit protesting loudly.

But DURGA stands in his way as he follows and she closes the door.

DURGA: I'm not a fool and neither are you. Let's talk straight and get this sorted.

HOBSON: You can't have Ali Mossop. For a start he's a Muslim, secondly he's half-cast and thirdly – his father was a hippy – and Ali's a come-by-chance…

DURGA: Eh?

HOBSON covers LORD GANESHA's ears.

HOBSON: …A bastard. His father shacked up with his mother and then legged it when Ali was born.

DURGA: Makes no difference to me. I'll have Ali Mossop. I've decided what I want so you'd better get used to it.

HOBSON: If I allowed it – I'd be the laughing stock of the Asian Small Businesses Association of Salford. I won't have it Durga.

HOBSON moves across to the statue of Ganesha, touches his belly and does pranam.*

It's indecent at your time of life.

DURGA: I'm thirty and I'm marrying Ali. And now I'll mek a deal with you.

HOBSON: You're hardly in a position to make deals.

DURGA: You will pay Ali the same wages as before. I've worked for sixteen years for you, free of charge. I'll do eight hours a day in future and you will pay me £300 per week.

HOBSON: D'you think I'm made of money?

DURGA: You'll be made of less money if you let Ali go. And if Ali goes, I go. Face facts.

HOBSON: I could face it Durga. Shop hands are cheap.

DURGA: Cheap ones are cheap. The type you'd have to watch all day to make sure they're not fiddling the books or robbing the till. Maybe you don't mind Jim, Rohan and Sanjay having a drink without you. I'm worth it and so's Ali. Imagine, you can show off at the The Nelson that you married me off to a decent, hard working man. If I were you, I'd put my hand in my pocket and do what I propose.

HOBSON: I'll show you what I propose.

HOBSON calls.

Ali Mossop!

HOBSON unbuckles his belt and places his hat on the counter.

I can't beat you. I never raised a hand to you but I can beat him. Come up Ali Mossop.

* Paying respect. An action where the person usually touches the feet of an elder in blessing.

ALI enters.

HOBSON conceals the belt.

You've taken a shine to my Durga I hear.

ALI: No, not me. It was her.

HOBSON: Well, Ali, either way, you've fallen on misfortune. Love's led you astray and I have to put you straight.

HOBSON shows the belt.

ALI: Durga, what's this?

DURGA: I'm watching you, my lad.

HOBSON: You can keep your job. I don't hold grudges but we must beat the love from your body and every morning you come here to work with love still sitting in you, you'll get a beating.

HOBSON gets ready to strike.

ALI: You can't beat love into me. You're making a great mistake Sahib, and…

HOBSON: You'll waste a lot of money at chemist's if I'm at you for a week with this.

HOBSON swings the belt.

ALI: I don't want your Durga, it's her that's after me but I'll tell you this Sahib – if you touch me with that belt, I'll take her quick, yes and stick to her like glue.

HOBSON: There's only one answer to that kind of talk, beta*.

HOBSON strikes ALI with the belt.

DURGA shrinks.

* Lad

45

ALI: And I've only one answer back. Durga, I didn't kiss you before. Allah be merciful, I'll kiss you now.

ALI kisses DURGA quickly, with temper, not with passion, and as quickly turns to face HOBSON.

And I'll take you and hold you. And if the Sahib raises that belt again, I'll do more. I'll walk straight out of shop with you and we two will set up for ourselves.

DURGA: Hey – Ali. I knew you had it in you!

HOBSON stands in amazed indecision.

ACT TWO

A month later. The shop as Act One. It is about midday. SUNITA is in DURGA's chair at the desk, in front of the computer, RUBY is sat applying some lip gloss and gazing at herself in a mirror. TUBBY stands near the desk by SUNITA.

SUNITA: I don't know what to tell you to do Tubby bhai.

TUBBY: There are no orders, nothing to do.

SUNITA: Well, Baba's out, in fact he never came home last night.

RUBY: Been on another bender.

TUBBY: So? What do I do?

SUNITA: I can't help you.

TUBBY: He'll go mad if he comes in and finds us doing nothing.

RUBY: Then do something. We're not stopping you.

TUBBY: I'm supposed to take my orders from the shop.

SUNITA: I don't know what to tell you. Nobody seems to want any suits made.

TUBBY: That's because all our regular customers seem to have disappeared. I suppose we can go on making cholis* for stock if you like.

SUNITA: Then you'd better.

TUBBY: Selling sari blouses won't pay the rent, let alone wages, but if *cholis** are your orders, Memsahib...

TUBBY heads down the trap.

SUNITA: You suggested it.

* Sari blouses

47

TUBBY: It was just a suggestion. But I'm not going to be responsible to the Sahib especially with him being in such a bad mood since Memsahib Durga went.

SUNITA: Oh dear! What would Durga have told you to do?

TUBBY: I don't know but things were never as slack as this in her time.

RUBY: You're no help. You're supposed to be an intelligent foreman.

TUBBY: When you've told me what to do, I'll use my intelligence and see it's done properly.

SUNITA: Then go and make some sari blouses.

TUBBY: Those're your orders?

SUNITA: Yes.

TUBBY: Thank you Memsahib.

TUBBY exits to the workshop.

SUNITA: Did I do the right thing?

RUBY: I dunno.

SUNITA: Baba should be here telling them what to do.

RUBY: Durga used to manage without him.

SUNITA: Fine, go on, blame me. It's all my fault business is so crap.

RUBY: I'm not blaming you. I know it's Baba's fault. He should be looking after his business instead of getting more pissed than usual in the The Nelson – but there's no point in snapping at me.

SUNITA: I'm not snapping. It's this bloody computer. I can't work out this spreadsheet – it's so complicated! I wish I was married and out of here.

RUBY: Me too. Mind you, Durga's spoilt our chances forever. Who's gonna want Ali Mossop as a brother-in-law?

SUNITA: Tell me about it.

DURGA enters followed by ROBBIE and ALI.

ROBBIE is dressed casually but looks smart.

SUNITA: Durga, you're here!

DURGA: I thought we'd just drop in. And look who I bumped into?

ROBBIE: We had a nice little chat.

RUBY looks suspiciously from DURGA to ROBBIE.

DURGA: He's been telling me all about you and him.

RUBY: So now you know.

ROBBIE: (*Grinning.*) She extracted the information from me Ruby. I was helpless.

RUBY: You should mind your own business Durga.

DURGA: From what I've heard of Baba's carryings on, you won't get far on your own steam.

RUBY: That's your fault. Yours and his.

She indicates ALI who is trying to efface himself at the back.

DURGA: (*Sharply.*) Enough of that. I'm here to help you.

RUBY is about to say 'no' but ROBBIE butts in.

ROBBIE: Thank you Durga. Your Baba's being a bit of a pain.

RUBY: That's the understatement of the century.

DURGA: He'll change – you'll see. Has your boyfriend been in yet this morning, Sunita?

SUNITA: (*Indignantly.*) My boyfriend –

DURGA: Steve Prosser.

SUNITA: No.

DURGA: Do you expect him?

SUNITA: He's hardly been in since you and Ali got –

DURGA: (*Sharply.*) Since when?

SUNITA: Since you forced him to buy a suit he didn't want.

DURGA: I see. I need to talk to him. Jacobs and Cohen, Solicitors of Bexley Square. That's right isn't it?

SUNITA: Yes.

DURGA: Bit of a big shot in't he?

SUNITA: Yeah – so?

DURGA: Could you phone him and fill him in on the details Robbie?

RUBY: Bossing people about a bit aren't you?

DURGA: I'm used to it.

ROBBIE: (*To RUBY.*) It's all right.

RUBY: Is it? Suppose Baba comes back and finds Robbie here?

DURGA: He won't.

SUNITA: He's late already.

DURGA: I know. You must have really hassled Baba since I left.

SUNITA: Blame us won't you.

DURGA: Tell them Robbie.

ROBBIE: Fact is, Mr Hobson won't come because he's out in Peel Park.

RUBY: What's Baba doing there?

ROBBIE: Pissed as a fart. I saw him meself – out for my early morning jog – you know how I like to keep myself fit Ruby. Anyway, there he was trying to have a wazz in the bushes. I thought – that's our Ruby's dad that is. My future father-in-law. He was swaying this way and that and the next you know, he'd keeled over.

RUBY: Is he hurt?

ROBBIE: He's snoring very loudly but I don't think he's hurt. He fell on some soft grass.

ROBBIE laughs.

Should've seen the state of him.

DURGA: Now you can phone Steve.

SUNITA: What's Steve gotta do with this?

DURGA: You'll see.

SUNITA: Is that all we're gonna be told?

DURGA: It's all there is to tell till later. (*To ROBBIE.*) You phone him in there. You'll have more privacy.

ROBBIE: (*To RUBY.*) I'll not be long.

ROBBIE pulls out his mobile phone and starts to dial a number.

DURGA: Don't be long. I've a job here for you when you get back.

ROBBIE exits to the back room.

SUNITA: I don't know what you're up to Durga, but …

DURGA: The difference between us is that I do. I always did.

RUBY: (*Indicating ALI.*) Bit of an odd choice there.

DURGA: (*Taking ALI's arm.*) I've done extremely well and I've come to straighten things out for you. Baba told you to get married and you've done nothing about it.

SUNITA: He changed his mind.

DURGA: I don't allow people to change their minds. He made his choice. He said get married and you're going to.

RUBY: You haven't made it any easier for us, you know.

DURGA: Meaning Ali?

ALI: It wasn't my fault Memsahib Ruby, really it wasn't.

DURGA: You call her Ruby, Ali.

RUBY: No he doesn't.

DURGA: He's in the family or going to be. And I'll tell you this. If you want your Robbie and if you want your Steve, you'll show respect to my Ali.

SUNITA: Ali Mossop was our tailor.

DURGA: He was and you'll let bygones be bygones. He's as good as you are now and better.

ALI: Nah, come Durga.

DURGA: Better, I say. They're just shop assistants. You've got your own label.

DURGA produces a card.

That's his business card: Ali's Shed, exclusive tailor/ quality artisan, 39a Oldfield Road, Salford. Ali Mossop. Ali Mossop, exclusive tailor! That's the man you're

privileged to call by his first name. And I'll do more for
you than that. Both of you can kiss your brother-in-law
to be.

ALI: Nah, Durga, I'm not great at kissing.

DURGA: (*Dryly.*) I've noticed that. A bit of practice won't
harm you. Come on Ruby.

SUNITA: His own label?

DURGA: (*Grimly.*) I'm waiting, Ruby

ALI: You don't have to force her.

DURGA: Chup*!

SUNITA: But how did you manage it? Where did the
capital come from?

DURGA: It came. Ali. Stand still.

ALI: I don't want to trouble her.

DURGA: You'll take your proper place in this family,
trouble or no trouble.

RUBY: Why d'you always get your own way?

DURGA: Habit. Come on now Ruby, I've got a lot on
today and you're holding everything up.

RUBY: It's under protest.

DURGA: Protest, but kiss.

*RUBY kisses ALI, rather stiffly and without any warmth.
ALI finds he likes it. RUBY moves back.*

RUBY: Your turn now Sunita.

SUNITA: I'll do it if you'll help me with this spreadsheet. I
was trying to do the accounts on it.

DURGA: You taken over my old job?

* Shush!

53

SUNITA: Yes.

DURGA: Sort it out yourself.

SUNITA: You could help me.

DURGA: I'm surprised at you, I really am, after what you've just been told. Exposing your accounts to a rival shop. You ought to know better. Ali's waiting. And I want you to give him a good, sisterly kiss.

SUNITA: All right.

SUNITA kisses ALI. It's more warm than RUBY's and it lasts a little too long.

ALI: Hmmm…nice.

DURGA: Don't get too fond of it.

SUNITA: Satisfied? Got your own way – as ever. Now, maybe you'll tell us if there's anything you want in this shop?

DURGA: Eh? Are you trying to sell me something?

SUNITA: I'm asking you, what is your business here?

DURGA: Ali and me's taking a day off to get you married.

RUBY: Things must be slack in your shop if you can wander around playing at being a matchmaker.

ALI: It's my wedding-day.

SUNITA: You got married this morning!

DURGA: Not yet. I want my sisters to be there. It's at one o'clock at Salford Central Registry Office.

RUBY: But we can't leave the shop.

DURGA: Why not? You that busy?

RUBY: No, but –

DURGA: Can't see any customers. You won't miss anything by coming with us to the Registry Office and we'll expect you at home tonight for a wedding-meal.

RUBY: You're asking us to approve.

DURGA: You have approved. You've kissed the groom and Baba's safe where he is.

SUNITA: And the shop?

DURGA: Tubby bhai can look after the shop. And that reminds me. You can sell me something. There are some rings in the drawer there Ruby.

RUBY: Brass rings?

DURGA: Yes. I want one. That's the size.

She holds up her wedding ring finger.

RUBY: You can't do that!

RUBY puts the box of rings on the counter.

DURGA: Yes I can. Ali and I aren't doing the traditional thing – seeing as we're different religions – might as well have a wedding ring.

SUNITA: But we're not even Christian.

DURGA: So? We aren't throwing good money around, but we can pay our way. There's twenty pence for the ring. Take it Ruby.

DURGA puts twenty pence on the counter.

SUNITA: Married with a brass ring!

DURGA: This one will do. It's a nice fit. Sunita, you haven't entered that in the spreadsheet. No wonder you're worried with the accounts if that's the way you see to them.

DURGA puts the ring in her bag.

SUNITA: A ring out of stock!

RUBY: I'd be mortified to be married with a ring like that.

DURGA: When you can't afford the best, you have to do without.

RUBY: I'll make sure I never go without.

DURGA: Detached house for you I suppose and a houseful of new furniture.

SUNITA: Haven't you furnished?

DURGA: Partly. We bought some stuff at the Patels' junk shop.

SUNITA: The Patels? I'd stay single rather than have other people's cast-off junk in my house. Where's your self-respect Durga?

DURGA: I'm not getting married to help the furniture trade. I suppose you'd turn your nose up at second-hand stuff too Ruby?

RUBY: I'd start properly or not at all.

DURGA: Then neither of you'll have any objections to my clearing out the spare room. We borrowed 'Claire the Clown's' van.

RUBY: Whose van?

DURGA: Claire – Jim's wife. She said we could use it for the afternoon but we've got to get it back to her by six – she's got a kid's birthday party to do.

ALI takes off his coat.

RUBY: Got it all worked out haven't you?

DURGA: Yes. Off you go Ali. I told you what we need.

SUNITA: Hold on.

DURGA: What?

ALI goes into the house.

SUNITA: You can't take the furniture from the spare room. You don't live here anymore, so by rights it belongs to the business.

DURGA: I thought you'd try and pull a fast one Sunita. But I said the spare room. There are two-three broken chairs, a table and a sofa with all the springs gone in there. Don't tell me you want them?

SUNITA: What d'you want with them?

DURGA: Ali's good with his hands. He'll fix them this afternoon and then when you come for dinner tonight, you can sit on them.

RUBY: And that's the way you're going to live! With crappy old furniture.

DURGA: Aye, in a shed in Dr Bannerji's garden.

SUNITA / RUBY: A shed!

DURGA: Yes, a shed, a portaloo and we'll shower at the leisure centre.

SUNITA: It wouldn't suit me.

RUBY: Me neither.

DURGA: It's fine for me. And when me and Ali are richer than the lot of you together, we can look back and remember where we came from.

ALI appears with two odd-looking broken chairs and begins to cross the shop.

RUBY: Hold up Ali.

RUBY examines the chairs.

These chairs aren't so bad.

DURGA: You can sit on one tonight and see.

RUBY: Fixed up, these chairs would look nice in my kitchen when I'm married.

SUNITA: Yes, or for mine.

DURGA: I reckon my shed comes before your kitchens though.

DURGA crosses to doors and opens them.

Put the chairs in the back of the van Ali.

ALI goes out into the street.

DURGA: And as for your kitchens, you haven't even got any yet. If you want my plan to work, remember all I'm taking off you is some battered old chairs that don't belong to you and what you'll be getting is weddings.

RUBY: Weddings?

ROBBIE re-enters.

ROBBIE: He should be here any minute.

DURGA: (*To RUBY and SUNITA.*) Better put your coats on or you'll be late at the Registry Office.

RUBY: But can't you tell us what you're doing about Baba first…

STEVE enters the shop from the street.

SUNITA: Steve…what are you doing here?

STEVE: I was told your sister had a plan.

SUNITA: What plan?

DURGA: (*Shooing the girls to the exit.*) You'll know soon enough. Be quick and get your things now.

RUBY and SUNITA exit.

DURGA: (*Turns.*) You filled him in?

ROBBIE: He's well up for it.

STEVE: Your wish is my command.

ALI re-enters from the street.

DURGA: Good. All we need from you is a bit of acting. Let's hope you're good at bullshitting Steve.

ROBBIE: 'Course he is. He's a lawyer.

DURGA: (*To ROBBIE and STEVE.*) Now – I've a job here for you. You two go into the spare room with Ali. There's a sofa to come out.

ROBBIE: But –

DURGA: If that sofa isn't here in two minutes, I'll leave the lot of you to tackle this yourselves.

ROBBIE: All right Durga.

STEVE and ROBBIE grudgingly go upstairs to the spare room to fetch the sofa.

DURGA: A quarter-to-one!

She calls out.

Girls, if you're late for my wedding I'll never forgive you.

DURGA hurriedly puts on her coat and gloves. She checks herself in the mirror and momentarily looks worried.

ALI, STEVE and ROBBIE enter with a battered old sofa and then lug the settee out.

DURGA looks at her watch.

ALI, STEVE and ROBBIE return.

DURGA: Now then Robbie, you wrote that letter?

ROBBIE: Yep.

DURGA: Read it out then.

ROBBIE produces a letter from his pocket and reads it out loud.

ROBBIE: 'Mr Hobson, My name is Robbie Ash and I'm a photographer for the Salford Herald. Having chanced across you this morning I feel that you would be the perfect candidate to illustrate an article in our newspaper on alcoholism and its detrimental effects on the local community in Salford. Hopefully it will shock enough youngsters not to stray into the path of drink and depravity and to that effect I have snapped a few photos of your inebriated, prostrate body for my newspaper. This is just to let you know that you will be appearing in the Herald on Thursday this week. Yours sincerely, Robbie Ash.'

STEVE: Nice one Rob.

DURGA: Yes. That should put the wind up him. Now take that letter and put it on my Baba in Peel Park.

ROBBIE: Now?

DURGA: Of course now. He might wake up at any moment.

ROBBIE: He was out cold. Can't I come to the registry office?

DURGA: Yes, if you do that quick enough to get there before we're through.

ROBBIE: All right.

ROBBIE exits, pocketing the letter.

DURGA: Now there's that van. Shall I take it with us?

STEVE: You can't turn up for your wedding in a clown's van full of old furniture. It's undignified.

DURGA: You brought your car Steve?

STEVE: How else did you think I got here so fast?

DURGA: It's a Mazzarati isn't it?

STEVE: Yep, leather interiors, air con and a wicked sound system. I'll give you a lift to the registry office in it if you like. You can arrive in style and it'll turn a few heads.

DURGA: Can't leave the van here though. (*Putting out her hand.*) Give us your car keys.

STEVE looks shocked.

Come on. I'll drive me, Ali and the girls over in your car and you can take the van back to ours. Just leave it outside our house and then you can catch a cab over to the registry office. Should be enough time.

STEVE: I'm not driving that van! It's bright purple and it's got 'Claire the Clown' written all over it.

DURGA: So?

STEVE: So…suppose one of my friends see me in it?

DURGA: Look here, my lad. If you're too proud to do a job like that, you're not the husband for my sister. It's not as if I'm asking you to dress up as a clown.

STEVE: As good as… I'll look bloody ridiculous.

DURGA calls out down the trap.

DURGA: Tubby bhai!

TUBBY: (*Off.*) Yes Memsahib. (*He appears in the doorway.*) Why it's Memsahib Durga!

DURGA: Come in Tubby bhai. You're in charge of the shop. We'll all be out for a while.

TUBBY: I'll be half a minute.

TUBBY disappears for a moment.

DURGA looks at STEVE.

DURGA: Well?

STEVE is resistant.

It is my wedding day.

STEVE grudgingly gives over his keys whilst DURGA hands over the van's keys.

STEVE: Mind how you drive it though.

DURGA: We'll call it your wedding gift to me and I'll allow you're putting yourself out a bit for me.

STEVE: Just a bit.

STEVE exits.

DURGA: Well Ali, you've hardly said a word today. How're you feeling?

ALI: I'm going through with it.

DURGA: Eh?

ALI: My mind's made up. I'm ready.

DURGA: The registrar's going to ask you will you have me and you'll either answer truthfully or not at all. If you don't want to, just say so now and –

ALI: I'll tell him 'yes'.

DURGA: And truthfully?

ALI: Yes. I'm getting used to it and you're growing on me – I'll stick with you.

ALI produces a small red sequined veil from his pocket and places it over DURGA'S head. Suddenly, she looks like an Indian bride.

RUBY and SUNITA enter. They have taken off their salwaar kamizes, let their hair down and are dressed in the outfits which HOBSON objected to in the first act.

SUNITA: We're ready.

DURGA: About time too. It's not your weddings you're dressing up for. (*By the door.*) Come on Tubby bhai – we need you to keep an eye on things.

RUBY: (*To ALI.*) Have you got the ring?

DURGA: I have. D'you think I'd trust him to remember?

DURGA links arms with ALI and they move towards the door. SUNITA and RUBY follow.

TUBBY pops up from the trap door with a conch shell in his hand. He blows it loudly.

They all turn and look at him shocked.

TUBBY: (*Apologetic.*) It's an old Indian custom.

They all laugh and exit.

TUBBY takes his tape measure from around his neck and hangs it around the statue of GANESHA. He leans against the elephant god and surveys the shop with pride.

ACT THREE

The shed in Dr Bannerji's garden is at once a workroom, shop and living room – all rolled into one. The bedroom is off to one side. A sewing machine stands against the wall.

Seating consists solely of the sofa and the two chairs taken from Hobsons', now repaired. STEVE, ROBBIE, DURGA and ALI are all sat on the sofa whilst SUNITA and RUBY are doing their dance routine from the beginning of Act One. At the end, everyone applauds and then stands and raises their tea cups and chant together:

ALL: The bride and groom.

> *They drink and sit. General laughter and chit chat. The dining table is littered with evidence of a feast with take away, Indian curry containers and a plate of Indian sweetmeats. There is also a vase of flowers.*
>
> *DURGA is on the chair downstage and ALI is now rising to stand behind the table, looking nervous. STEVE hammers on the table, SUNITA stops him.*

ALI: It's a very great pleasure to us to see you here tonight. It's an honour you do us and I assure you, speaking for my – my wife, as well as for myself, that the – the –

DURGA: (*Whispers.*) Generous.

ALI: Yes, yes, that's it. That the generous warmth of the sentiments so beautifully expressed by Mr Ash and so enthusiastically seconded by – no, I've got that the wrong way round – expressed by Mr Prosser and seconded by Mr Ash – will never be forgotten by either my life partner or myself – and – and I'd like to drink this toast to you in my own house. Our guests, and may they all be married soon themselves.

DURGA: (*Rising.*) Our guests.

ALI and DURGA sit. General laughter and conversation.

STEVE: (*Solemnly rising.*) I've known Durga and Ali for a relatively short time but I feel…

SUNITA tugs his sleeve and pulls him down.

SUNITA: Sit down. I don't think I could bear another one of your rambling speeches.

STEVE: We should thank him.

SUNITA: Yes but you can't speak as well as Ali, so just leave it out. Ali, I must admit, I underestimated you.

ROBBIE: Very good speech indeed.

RUBY: Who taught you?

ALI: I've been learning a lot recently.

SUNITA: I didn't think Ali talked much let alone made speeches!

DURGA: I'm educating him.

ROBBIE: And a very good pupil he is too.

DURGA: He'll do. Another twenty years and I know which one of you three men'll be thought most of at the Bank.

ROBBIE: (*Good natured.*) Charming!

DURGA: I'll admit it needs imagination to see it now.

STEVE: It's a good start. Snug little shed, a label of your own. How did you raise the capital for this Durga?

DURGA: I? You mustn't call it my label. It's his.

SUNITA: You telling me Ali found the capital?

DURGA: He's the saving type.

SUNITA: On what Baba used to pay him?

DURGA: We've had help.

STEVE: Ah!

RUBY: Who from?

DURGA: Same place as where those flowers and this shed came from.

RUBY looks at the flowers

SUNITA: Well, I think we ought to be getting home. Durga, we need the loo.

DURGA: I'll show you, it's outside.

RUBY: Outside?

RUBY and SUNITA share a horrified look.

DURGA: It's perfectly clean.

DURGA is going through a back door to the shed with SUNITA and RUBY, then stops.

Ali, we'll need this table when they're gone. You'd better clear the things away.

ALI: All right.

ROBBIE: But you – ?

STEVE: Bloody hell – hen-pecked already.

STEVE and ROBBIE both laugh.

DURGA: (*Quite calmly.*) And you and Robbie can just lend him a hand with the washing up.

ROBBIE: Me, wash plates? Now?

RUBY: (*Outraged.*) Durga, we're guests.

DURGA: I know. And this is my wedding day. You'll find the tap in the garden with a hose attached to it.

DURGA ushers SUNITA and RUBY out, and follows.

ALI begins to put plates on a tray.

ROBBIE and STEVE look at each other, then at ALI, then at each other again.

STEVE: You gonna do the washing up?

ROBBIE: Are you?

STEVE: Look at it this way. If it all goes well, me and you are marrying into this family and we know what Durga's like. If we give in to her now, God help us for the rest of our lives.

ROBBIE: You got a point, but there's this plan of hers…and we got to keep her sweet.

STEVE: But washing up! With a hose! I'm used to loading things in a dishwasher.

ROBBIE: Pretend we're on a camping expedition.

They look at ALI who is clearing the table.

What would you do in our place, Al?

ALI: Me? I'm doing as I'm told.

ROBBIE: You're married to her. We aren't.

STEVE: What d'you need the table for in such a hurry?

ALI: I'm in no hurry.

ROBBIE: Durga wants it for something. Wedding night spent on the table eh? Very kinky.

ROBBIE and STEVE guffaw.

ALI: It'll be for my English lessons. She's teaching me.

ROBBIE: English lessons eh? Very romantic.

ALI: But you don't need to go yet.

67

STEVE: You want us hanging around on your wedding night?

ALI: Please don't go – not yet.

ROBBIE: He's afraid to be on his own with her. That's what it is. He's scared of his wife.

They laugh.

ALI: I've never been married before and I've never been left on my own with her, either. 'Til now she's been visiting me at Tubby bhai's to give me my lessons. It's different now and I have to admit, I'm feeling…well… I'd be deeply obliged if you would stay on a bit to help to – to thaw the ice for me.

ROBBIE: You've been engaged to her, haven't you?

ALI: Yes, but not for long. And Durga's not the sort you get 'familiar' with.

ROBBIE: You had quite long enough to thaw the ice. It's not our job to do your melting for you.

STEVE: These plates need washing. Let's get on with it before he asks us to explain the facts of life.

STEVE starts washing up whilst ROBBIE is clearing the table.

ALI continues.

ALI: Rob, would you like it yourself with – with a woman like Durga?

ROBBIE: Like it? What d'you mean?

ALI: You know.

ROBBIE: It wasn't me she married.

ALI: It's being alone with her that worries me. I thought you might help me out.

STEVE: Now steady on Al. You want me to whisper instructions to you from the garden or something?

ALI: No but...you could give me a few pointers.

STEVE: That's not the way it's done. (*Calls out.*) Rob, hurry up with those plates.

DURGA enters with SUNITA and RUBY.

DURGA: Have you broken anything yet, Steve?

STEVE: (*Indignant.*) No.

DURGA: Too slow, I expect.

ROBBIE: You could be a bit grateful.

STEVE: Aren't you surprised to find us doing this?

DURGA: Surprised? I told you to do it.

ROBBIE: Yes, but –

DURGA takes the tea towel from him.

DURGA: You can stop now. I'll finish it off.

There is a loud banging on the shed door.

We hear HOBSON's voice.

HOBSON: (*Off.*) Durga? Durga! Are you in?

RUBY: (*Terrified.*) It's Baba!

STEVE: Shit.

DURGA: What's the matter? Are you afraid of him?

ROBBIE: No, but he won't be happy to see us here will he?

DURGA: You can all go into the portaloo...no not you Ali. The rest. I'll call when I want you.

SUNITA: When he's gone.

DURGA: It'll be before he's gone.

RUBY: But we don't want –

DURGA: Is this your home or mine?

RUBY: It's your shed.

DURGA: And I'm in charge of it.

The four go into the portaloo.

RUBY starts to argue but she is pushed inside.

(*To ALI.*) You sit still and don't forget, you're the man of the house. I'll get the door.

ALI sits in a chair at the head of the table.

HOBSON enters. He looks haggard and is smoking a cigarette.

HOBSON: Well…Durga.

DURGA: (*Uninviting.*) Well, Baba.

HOBSON: (*Hesitant.*) I'll come in.

DURGA stands in his way.

DURGA: Hold on… I'll have to ask the man of the house first.

HOBSON: Eh?

DURGA: You two didn't exactly part on the best of terms, remember? Ali, it's my father. Can he come in?

ALI: (*Loudly and boldly.*) Enter.

HOBSON steps forward. He stares around the shed.

HOBSON: Not exactly very polite in your welcome, young man.

ALI shakes his hand for a long time.

ALI: Oh, but I am. I'm very glad to see you Mr Hobson. It makes the wedding day complete, you being her father and I – I hope you'll stay for a while.

HOBSON: Well –

DURGA: That's enough Ali. No need to overdo it. You can sit down for five minutes Baba. The sofa can just about cope with your weight. It's been tested.

ALI: There's only tea to drink and I think what's left in the pot is stewed, so I'll…

DURGA takes the teapot off him

DURGA: You'll do nowt of sort. Baba likes his liquids strong.

ALI: Some biryani Mr Hobson?

HOBSON: (*Groaning.*) Biryani!

DURGA: You'll be sociable now you're here, I hope.

HOBSON: It wasn't sociability that brought me Durga.

DURGA: What was it then?

HOBSON: Durga, I'm in disgrace. A terrible and sad misfortune's fallen on me.

DURGA: (*Offering a plate of sweetmeats.*) Have a laddoo*. It'll do you good.

HOBSON: (*Shuddering.*) It's sweet.

DURGA: That's natural in mithai**.

HOBSON: I've got a terrible head.

DURGA: I know it's silly, but I've a wish to see my Baba sitting at my table eating my wedding sweets on my wedding day.

* A type of Indian sweet – round and yellow. Very rich.
** Sweets

HOBSON: It's a very serious thing I came about Durga.

DURGA: It's not more serious than knowing that you wish us well.

HOBSON: You know my thoughts. When a thing's done it's done. You've had your way and done what you wanted. I'm not proud of the choice you made and I won't lie and say I am, but I've shaken your husband's hand and that's a sign for you. No point crying over spilt milk.

DURGA: Then there's your cake and you can eat it.

HOBSON: I've given you my word there's no bad feeling.

He pushes the sweets away.

DURGA: Get on with it Baba.

DURGA pushes the sweet back.

HOBSON: You're a hard woman. (*He eats.*)

DURGA: Now tell me what it is you came about?

HOBSON: I'm in deep trouble.

DURGA rises and walks towards the door.

DURGA: Then I'll leave you with my husband to talk it over.

HOBSON: What?

DURGA: You don't want me. Women get in your way. You said so yourself.

HOBSON: (*Rising.*) Durga, you're not going to desert me in the hour of my need, are you?

DURGA: Surely you don't want a woman's help! Ali'll do his best. Give us a shout when you've finished Ali.

HOBSON: (*Following her.*) Durga – it's private.

DURGA: That's why I'm going and you can discuss it man to man without any foolish women about.

HOBSON: I've come to see you, not him. It's private.

DURGA: Private from Ali. No it isn't. Ali's in the family and you've nowt to say to me that can't be said to him.

HOBOSN: I've got to tell you in front of him?

DURGA: Me and Ali's one.

ALI: Sit down Mr Hobson.

DURGA: You call him Baba now.

ALI: (*Astonished.*) Do I?

HOBSON: Does he?

DURGA: He does. Sit down Ali.

ALI sits right of table.

DURGA stands at the head of the table.

HOBSON sits on the sofa.

DURGA: Now, if you're ready Baba, we are. What's the matter?

HOBSON: That.

He producers a letter.

That's the matter.

DURGA takes the paper and passes it to ALI who looks at it studiously. DURGA moves and stands behind his chair and turns the letter the right way up. She and ALI read it together.

DURGA: What is it Ali?

HOBSON: Ruin, Durga, that's what it is! Ruin and bankruptcy. Am I the Salford Hindu temple Priest's right

73

hand man, Guardian of Lord Ganesha or am I not? Am I Hobson of Hobson's Tailor's on Chapel Street, Salford? Am I a respectable ratepayer and father of a family or –

DURGA: You're going to be in the local papers I see.

HOBSON: It's a stab in the back; it's an unfair, un-British, cowardly way of taking a mean advantage of a casual accident.

DURGA: Were you drunk?

HOBSON: Durga, I swear, it's all your fault. I'd been in the The Nelson and I'd stayed too long. And why? Why did I stay too long? To try to forget a thankless child, to erase from the tablets of memory the recollection of your conduct. That was the cause of it. And the result, the bloody result? I lapsed into unconsciousness in Peel park. I slept on the grass and I awoke to this catastrophe. This letter...publicity...ruin.

DURGA: This photographer's got incriminating evidence.

HOBSON: He took an unfair advantage of me. Bloody snooping paparazzi! He'll squeeze me dry for it.

ALI: My goodness and that's quite a squeeze.

HOBSON stares at ALI.

DURGA: I can see it's serious. You'll probably lose some business from this.

HOBSON: It's as certain as Diwali. My well-heeled customers aren't going have their clothes made by a man who's been labelled as an alcoholic. They won't remember it was private grief that caused it all. They'll only think the worse of me because I couldn't control my daughter better than to let her go and be the cause of sorrow to me in my age. That's what you've done. Brought this on me, you two, between you.

ALI: Do you think it will get into the paper Durga?

DURGA: Yes, for sure. You'll see your name in the Salford Herald Baba.

HOBSON: Salford Herald! Yes and more. When there's ruin and disaster and outrageous fortune overwhelms a man of my importance in the community, it isn't only the Salford Herald that'll take note of it. Radio Salford, Manchester Guardian, The Asian Times, Eastern Eye, India Weekly…Asian Age…the whole of Lancashire, my Asian brethren around the country and the entire Indian sub-continent will read about me. I can see it now: 'Tanked up tailor – paralytic in Peel Park.' The shame, the shame.

ALI: Heh Allah. Think of that! You'll have your name appearing in all those papers. It's nearly worthwhile being ruined just to have the pleasure of reading about yourself in the papers.

HOBSON: Everyone will read it. They'll gloat.

ALI: You're right. I didn't think of that. This will give a lot of satisfaction to a lot of people. People read papers mainly to read about their neighbours' troubles. And when they see it's you – well everyone knows you Mr Hobson – they'll lap it up.

ALI is perfectly simple and has no malicious intention.

HOBSON: To hear you talk it sounds like a pleasure to you.

ALI: No, it's not. You ate my wedding sweets and you've shook my hand. We're friends I hope and I was only talking as a friend. I always think it's best to look on the worst side of things first, then whatever happens can't be as bad as you imagined. Mind you, there's Salford Central Temple. I don't suppose you'll go on being the

Priest's right hand man after this affair and it brought you a lot of customers from the community centre.

HOBSON: (*Turns to DURGA.*) Your husband's not being very helpful.

DURGA: It's about what you deserve.

HOBSON: Have you got any more words of comfort Ali?

ALI: (*Aggrieved.*) I only spoke what came into my mind. I can keep my mouth shut if you want.

HOBSON: Don't strain yourself Ali Mossop. When a man's mind is full of thoughts, they're better out than in.

ALI: I'm not very good at talking and I always seem to say wrong things. I'm sorry if my well-meant words don't go down well but I thought you came here for advice.

HOBSON: I didn't come to you, you jumped-up, loud-mouthed…

HOBSON stands up, all worked up.

DURGA: That'll do Baba. (*She pushes him down.*) My husband's trying to help you.

HOBSON glares impatiently for a time

HOBSON: (*Meekly.*) Yes Durga.

DURGA: Now, about this incident.

HOBSON: Yes Durga.

DURGA: It's the publicity you're most afraid of?

HOBSON: Yes. It'll be the ruin of everything I've worked for. Me that's voted right all through my life here and been a loyal supporter of the Queen and constitution.

DURGA: I've heard of these sorts of cases being settled through lawyers.

HOBSON: I won't go near a court.

DURGA: We could settle out of court, in private.

HOBSON: You mean settled in a lawyer's offices behind closed doors so no one can see they're squeezing twice as hard in private as they'd dare to do in public. At least there's some restraint demanded by a public place, but privately! It'll cost a fortune.

DURGA: Of course it'll cost you something, but if you don't mind the publicity…

HOBSON: Only if it's not in a lawyer's office.

DURGA: You can settle it with a lawyer out of his office. You can settle with him here.

DURGA goes and opens the back door.

Steve!

Enter STEVE who leaves the door open.

This is Mr Prosser of Jacobs and Cohen.

HOBSON: (*Amazed.*) He is!

DURGA: Yes.

HOBSON: (*Incredulously rising.*) You're a lawyer?

STEVE: I'm a solicitor.

HOBSON is disgusted almost too deep for words.

HOBSON: At your age!

DURGA goes up to the door.

DURGA: Come out, all of you.

There is reluctance inside, and then RUBY, SUNITA and ROBBIE enter and stand in a row.

HOBSON: Sunita! Ruby!

DURGA: Family gathering. This is Mr Ash.

ROBBIE: How do you do?

The situation is plainly beyond HOBSON.

HOBSON: What! Here! You blood-sucking, cowardly snake of a man. You…

DURGA: That's quite enough Baba. When you've got a thing to settle, you need all the parties to be present.

HOBSON: But there are so many of them. Where have they all come from?

DURGA: My toilet.

HOBSON: Your…? Durga, please explain before my brain explodes.

DURGA: It's quite simple. I got them here because I expected you.

HOBSON: You expected me?

DURGA: Yes. You're in trouble.

HOBSON: What's it got to do with Sunita and Ruby? What are they doing here?

SUNITA: We closed up for the day.

HOBSON swells with rage.

HOBSON: And do you run that shop? Do you give orders there? Do you decide when you can put on your shameless skirts, bare your legs and walk out?

DURGA: They've come because it's my wedding day, Baba. It's a good enough reason and me and Ali will do the same for them. We'll close the shed and welcome on their wedding days.

HOBSON: Their wedding days! That's a long time off. It'll be many a year before there's another wedding in this

family, I give you my word. (*Turns to DURGA.*) One
daughter defying me is quite enough.

STEVE: Shouldn't we get down to business, sir?

HOBSON: (*Turning on STEVE.*) Young man, don't abuse a
noble word. You're a lawyer. By your own admission
you're a lawyer. Honest men live by business and
lawyers live by law.

STEVE: In this matter sir, I am here to advise you.
Following the instructions of my client, Ms Durga
Hobson…

HOBSON: How did you know about this situation in the
first place?

DURGA: Mr Ash told me about it and so I called on Mr
Prosser's services…

HOBSON: (*To ROBBIE.*) Blackmail eh? I might have
guessed…

ROBBIE: You can call me all the names you like –

HOBSON: And I shall. You spineless piece of scum.

DURGA: Mr Ash has kindly agreed to sell us the photos he
took of you.

STEVE: And I wish to remind you, in your own interests,
that abuse of a photographer will not help your case. He
tells me that he is prepared to settle this matter out of
court. He has no desire to be vindictive. He remembers
your position, your reputation for respectability and…

HOBSON: How much?

STEVE: Er – sorry?

HOBSON: I'm not so fond of the sound of your voice as
you are. What's the figure?

STEVE: The sum we propose, which will include my ordinary costs, but not any additional costs incurred by your use of defamatory language, is four thousand pounds.

HOBSON: What!

DURGA: It isn't.

HOBSON: Four thousand pounds for getting pissed?

ROBBIE: You've just admitted it – Mr Hobson – you were drunk. I think people would be very interested to see with their own eyes how a stalwart of the local Asian community has succumbed to drink. And I also hear you keep your daughters under lock and key, make 'em slave away in that shop of yours for nothing…

HOBSON: I do not!

ROBBIE: Could make quite an article though. 'Boozing Bengali businessman beats his bairns.'

HOBSON: How dare you.

HOBSON lunges at ROBBIE.

STEVE bars the way.

STEVE: Or: 'Suits You Sir sozzled in shrubs'.

RUBY: Or: 'Blottoed bully canned on common.'

ALI: What about: 'Pompous Paki Pissed in Park.'

HOBSON looks cornered.

STEVE: In my professional opinion Mr Hobson – you should agree to his terms and…

HOBSON: He's an immoral, unprincipled scoundrel. A member of the filthy Paparazzi.

ROBBIE: Now I see how desperate you are to keep your picture out of the papers I'd be inclined to ask for more

money. I think they'd sell for a high price. Papers'd love to get hold of them.

HOBSON: It's people like him killed our Princess Di! Hounding good honest British citizens for his pleasure.

ROBBIE: I think I'll add an...erm...an...

STEVE: Appendage.

ROBBIE: Right. You pay me four thousand pounds plus an assurance that you will free your daughters.

HOBSON: They're not prisoners.

ROBBIE: That's not what I've heard. I think our readers would be very...

HOBSON: He's nothing more than a criminal. A professional blackmailer.

DURGA: Hey, Robbie Ash – I can see you're going to get on in the world but there's no need to be greedy. That four thousand's too much.

ROBBIE: I thought –

DURGA: Then you can think again.

ROBBIE: But –

DURGA: If there are any more signs of greediness from you, there'll be a counter action for slander.

HOBSON: Durga, you've saved me. I'll bring that action, I'll sue, I'll show him...

DURGA: Now let's be done with this. I know very well what Baba can afford to pay, and it's not four thousand pounds nor anything near that figure.

HOBSON: Less of your 'can't afford', Durga. I'm not a pauper.

DURGA: You can afford two thousand pounds and you're going to pay two thousand pounds.

HOBSON: Oh, but there's a difference between affording and paying.

DURGA: Then be reported in the papers and have your mug shot all over the centre pages if you like.

HOBSON: It's the principle I care about. I'm being beaten by an employee of the gutter press.

RUBY: Baba, dear, how can you be beaten when he wanted four thousand pounds and you're only going to give two?

HOBSON: I hadn't thought of that.

RUBY: He's the one who's been beaten.

HOBSON: I'd take a few good beatings myself at that price Ruby. Still, I want this kept out of the public eye.

STEVE: Then we can take it as settled? You will agree to payment of two thousand pounds and a promise that your daughters can have their freedom.

HOBSON: Do you want to see the money before you believe me? Is that your nasty lawyer's way?

ROBIE: The sooner you pay, Mr Hobson, the sooner I can delete these.

ROBBIE holds out his digital camera and shows HOBSON the photos.

HOBSON squints at them and then gasps in shame.

A cheque will do.

HOBSON is furious. He pulls out his cheque book and scribbles a cheque.

ROBBIE looks over his shoulder.

That's Mr Ash…and don't forget to sign it.

HOBSON: And don't you forget to delete those.

HOBSON tears out the cheque and hands it over to ROBBIE.

ROBBIE: Now you have to swear to allowing your daughters to do their own thing.

HOBSON: That's my own private affair.

HOBSON tries to snatch the camera but ROBBIE dodges his grasp.

ROBBIE: Ah, ah, ahhh… A promise is a promise.

STEVE: You did agree to the terms Mr Hobson.

HOBSON looks defeated.

HOBSON: Alright, alright…the girls can do as they please.

ROBBIE hands over the photos and then pulls out the negatives from his pocket, which he also hands over.

RUBY: (*She whoops.*) It's settled! It's settled!

HOBSON: What're you so happy about? I won't be dragged to public shame, but this is a tidy sum to be going out of the family.

DURGA: It's not going out of the family Baba.

HOBSON: Eh?

DURGA: Their wedding day is not so far off as you thought, now there's one thousand pounds apiece for them as a wedding present from you.

HOBSON: You mean to tell me…

STEVE and SUNITA and RUBY and ROBBIE stand arm in arm.

(*Rising.*) I've been swindled. It's fraud. It…

DURGA: It takes two daughters off your hands at once and clears your shop of all the fools of women that used to clutter up the place.

SUNITA: It'll be much easier without us in your way, Baba.

HOBSON: Hanh* – and you can keep out my way. Do you hear that all of you?

HOBSON starts to rant and swear in Hindi.

Sali….haramzadi.**

RUBY: Baba!

HOBSON: I'll run that shop with men – and I'll show Salford how it should be run. Don't think there'll be room for you when you come home crying and tired of your fine English husbands. I'm rid of you and it's a bloody relief. I'll pay this money that you've robbed me of and that's the end of it. All of you. You especially Durga. I'm not blind and I can see who it is I've got to thank for this.

HOBSON moves to leave.

DURGA: Don't be nasty Baba.

HOBSON: Ali Mossop, I feel sorry for you. She'll take you for everything – you're the best of the bunch. You're a backward lad but you know your trade and it's an honest one.

SUNITA: My Steve knows his trade too. He's a professional.

HOBSON: Professional liar. He's good at robbery.

SUNITA shows great indignation.

And I've got it on my conscience that my daughters married a lawyer and a Grub Street, gutter press photo hack.

* Yes (Hindi)
** Bastard (Hindi)

RUBY: It didn't worry your conscience to keep us slaving in the shop with no wages.

HOBSON: I fed and clothed you didn't I? It's someone else's job now. Yes, you two may grin but girls don't live on thin air. Wait till the kids start to come. Don't come running to me for help.

He is leaving.

SUNITA: Baba!

HOBSON: (*Turning.*) Yes, you may 'Baba' me. But I've done with fathering and they're beginning it. They'll know what marrying a woman means before long. Chaining themselves up and I've thrown the shackles off. I've suffered thirty years and more and I'm a free man from today. Bhagavan*, you have no idea what you're taking on. You poor, poor bastards. You're thieves and frauds but you're going to pay for it.

HOBSON exits.

The others all look at each other in shock.

DURGA: You'd better get married quick. Suni and Ruby'll have a sweet time with him.

ROBBIE: Can they go home at all?

DURGA: Why not?

ROBBIE: After what he just said?

DURGA: He'll hardly remember any of it – he's heading to The Nelson now – if there's time before last orders. What is the time?

STEVE: Time we were going; you'll be glad to see the back of us.

STEVE shows DURGA his watch.

* God/Lord

ALI: No, no. I wouldn't dream of asking you to go.

DURGA: Then I would. It's high time we turned you out.

DURGA gets STEVE's and ROBBIE's coats and hands them over to them.

Good night.

STEVE and ROBBIE glance at ALI who is a bag of nerves.

Good night Suni.

SUNITA: Good night Durga.

SUNITA and STEVE exit together.

DURGA: Good night Ruby.

RUBY: Good night Durga. And thank you.

DURGA: Oh that! I'll see you again soon; only don't come round here too much because Ali and me's going to be busy.

The general exit is continuous, punctuated with laughter and merry 'good nights!'.

DURGA: Ring us when you've got a date.

STEVE: We'll be glad to see you at the wedding.

DURGA: We'll definitely come to that 'cos afterwards you'll be too grand for us.

STEVE: Oh no Durga.

Everyone exits the shed.

DURGA waves them good night and then turns to look at ALI.

He looks nervous. He busies himself erecting a camp bed in the corner of the room whilst DURGA busies herself tidying up a little. ALI sits on the edge of the bed and tries to

concentrate on writing in his exercise book but his mind is obviously on other things.

DURGA enters carrying the vase of flowers. She puts them down by the bedside.

ALI: I keep re-reading the same sentence…seems so complicated.

DURGA: You heard what I said tonight. In twenty years you're going to be thought more of than either of your brothers-in-law.

ALI: I heard you say it, but if you don't mind me saying so – it's a bit of a dream.

DURGA: And we're going to make it come true. I'm not a show-off but I think you're going to make it in less than twenty years.

ALI: Well, I don't know, the others've got a long head start on us.

DURGA: And you've got me.

DURGA sits down next to ALI. He is jumpy. She looks at his book.

Is this what you did last night at Tubby bhai's after I came here?

ALI: Yes.

DURGA: 'There's always room at the top.' Your writing's improving Ali. I'll set you another short writing exercise for tonight because it's getting late and we've a lot to do in the morning. (*Writing.*) 'Great things grow from small.' Now, you can sit here and copy that.

ALI goes back to his book.

DURGA looks at ALI who is bent over his books and moves over to the vase. She takes a flower out of the vase.

ALI notices.

ALI: You're saving one.

DURGA is caught in the act of sentiment. She is embarrassed.

DURGA: I thought I'd press it for a memento. I want to remember today. (*She yawns.*) I'm tired. I was going to wash up but I think I'll leave the rest of those plates till morning. It's a lazy way of starting but I don't get married every day.

ALI is industriously reading.

ALI: No.

DURGA: You finish that off before you come to bed.

ALI nods nervously.

Exit DURGA to the portaloo.

ALI writes for a while. He looks shyly at the bed, sits and takes off his shoes. He rises, shoes in hand and stands unsure of what to do. He takes off his jacket and then sits down on the edge of the bed again, with occasional glances at the back door. He is uncomfortable.

DURGA re-enters from the portlaoo. She has let down her hair and is dressed for bed.

ALI sits up when he sees her. She sits on the edge of the bed, very close to him.

They kiss.

ACT FOUR

It is a year later. We are in HOBSON's shop early in the morning. TUBBY is barring JIM's way.

JIM: I'll go straight to him, Tubby.

TUBBY: He's getting up.

JIM: Getting up! I thought you said he was at death's door…

TUBBY: I only told you what he told me to. Run for Dr Bannerji, he said. And I ran for Dr Bannerji. Now go to Jim's shop, he said, and tell him I'm very ill and that's what I did. Then he said he would get up and I was to have his breakfast ready for him and he'd see you down there.

JIM: Nonsense Tubby. Of course I'll go in to see him.

TUBBY: You know what he's like. I'll get blamed if you go and he's in a foul mood this morning.

JIM: I don't want to get you into trouble…but I thought it was something serious.

TUBBY: It is.

JIM: In what way?

TUBBY: Every way you look at it. The Sahib's not the same and neither is the shop. And look at me! I ask you, man to man, is this work for an artisan? A foreman tailor? Playing nursemaid, serving breakfasts?

JIM: From what I hear there's not much else for you to do.

TUBBY: There are better jobs than being a housewife, even if it's only making sari blouses.

JIM: They tell me sari blouses are two-a-penny.

TUBBY: So what can I do? No one wants anything else. Hari Hobson's in a bad way – it's a known fact all around town.

JIM: Such a shame with an old-established trade like this.

TUBBY: And who's to blame? I've worked for the Sahib for nearly twenty years now and I'm sticking by him. Everyone calls me a door mat because I don't look after Tubby Mohammed first. If that doesn't give me the right to say what I want, I don't know what does. Hobson's a bad tempered, stubborn old bastard and he's run this shop down into the ground. He's tactless with the customers and he can't sell anything, not like Memsahib Durga. She used to sell the goods and made them come back for more.

JIM: Ali Mossop's doing well in Chapel Street.

TUBBY: Ali's a good boy and a genius tailor. I should know – I trained him. What with both him and the Memsahib gone – we've got men assistants in the shop. I ask you, when you go to buy clothes – do you like to be served by a man or a pretty, shapely young woman?

JIM: (*Embarrassed.*) Well…

TUBBY: There you are. Stands to reason. It's human nature.

HOBSON groans.

JIM enters the dinning area followed closely by TUBBY.

The place is a mess. Empty bottles and overflowing ashtrays litter the place.

HOBSON is sitting up in a makeshift bed in the room, which is unmade. He looks shabby and distressed.

JIM: (*With sympathy.*) Look at the state of you Hari!

HOBSON: (*With acute melancholy and self-pity.*) Oh, Jim, Jim, Jim...

JIM: Come and sit down at the table. Let me make your favourite breakfast. A fry-up – what d'you say?

HOBSON: The table? Breakfast? Bacon, and I'm like this.

JIM assists him to a chair and busies himself making HOBSON some breakfast.

JIM: When a man's like this he wants a woman about the house.

HOBSON: (*Sitting.*) Forget it.

TUBBY: Shall I go for Memsahib Durga? Mrs Mossop I mean?

JIM: I think your girls should be here.

HOBSON: They should but they're not. They're married and I'm deserted and I'll die deserted. When they see the flames of the funeral pyre lick my flesh, then perhaps they'll be sorry for the way they've treated me. Tubby have you got any work to do in the shop?

TUBBY: I might have some if I looked hard.

HOBSON: Then go and look.

TUBBY: Are you sure you wouldn't like Memsahib Durga here? I'll go for her and...

HOBSON: Oh, go for her. Go for Saitan*. What does it matter? I'm a dying man.

TUBBY exits.

JIM continues to prepare breakfast.

JIM: What's all this about dying?

* Satan, the devil

91

HOBSON: Oh, Jim, Jim, Jim! I've sent for the doctor. We'll know soon how near the end is.

JIM: This is all very sudden. You've never been ill in all the years I've known you.

HOBSON: It's all been stored up to hit me now.

JIM: What are your symptoms?

HOBSON: I'm all one symptom, head to foot. I'm frightened of myself. That's the worst. Would you call me a clean man?

JIM: Of course! Clean in body and mind.

HOBSON: I'm dirty now. I haven't washed this morning. Couldn't face the water. The only use I saw for the water was to drown myself. The same with shaving. I've thrown my razor out of the window. Had to or I'd have cut my throat.

JIM: Oh, come, come…

HOBSON: It's awful. I can't trust myself. I'm going to grow a beard – if I live.

JIM: Don't be ridiculous. What do you think's the cause of all this?

HOBSON: The Nelson.

JIM: You don't think…

HOBSON: I don't think. I know. I've seen it happen to others, but I never thought it would happen to me.

JIM places the breakfast in front of HOBSON, who turns away from it. TUBBY enters, showing in DR BANNERJI.

TUBBY: Here's Dr Bannerji.

DR BANNERJI: Good morning gentlemen. Where's my patient?

JIM: (*Speaking without indicating HOBSON.*) Here. (*He does not rise.*)

DR BANNERJI: Here? Up?

HOBSON: Looks like it.

DR BANNERJI: And for a patient who's sat up in bed I'm called at this hour?

JIM: It's not that early.

DR BANNERJI: But I've been up all night, sir. Young woman with her first. Which one of you is ill?

JIM: Not me.

DR BANNERJI: Hmmm… Not much to choose between you. You've both got your fate written on your faces.

JIM: What d'you mean?

DR BANNERJI: I mean he has and you will.

HOBSON: Dr Bannerji will you attend to me?

DR BANNERJI: Yes. Now…

DR BANNERJI sits by HOBSON and takes his pulse.

HOBSON: I've never been ill nor wanted a doctor in my life.

DR BANNERJI: You've needed but you've not sent.

HOBSON: But this morning…

DR BANNERJI: I know – well.

HOBSON: You know?

DR BANNERJI: Any fool would know.

HOBSON: Eh?

DR BANNERJI: Any fool but one fool and that's yourself.

HOBSON: You're damned impudent.

DR BANNERJI: If you want flattery, I dare say you can get it from your friend. I'm giving you ma medical opinion.

HOBSON: I want your opinion on my complaint, not on my character.

DR BANNERJI: Your complaint and your character are the same.

HOBSON: Then you'll kindly separate them and you'll tell me –

DR BANNERJI: (*Rising to exit.*) I'll tell you nothing, sir. I don't diagnose as my patients wish, but as my intellect and sagacity direct. Good morning to you.

JIM: But you haven't even diagnosed.

DR BANNERJI: Sir, if I am to examine a patient in the presence of a third party, the least the third party can do is to keep his mouth shut.

HOBSON: That's it. There's only one thing for it. Either she goes or I do.

JIM: I think I'd better go Hari.

HOBSON: There are other doctors Jim. *Male* doctors.

JIM: You should listen to the Doctor. If that's it, I'll leave you.

JIM exits.

DR BANNERJI: (*Sits down.*) That's better Mr Hobson.

HOBSON: Don't try bossing me around doctor. I can bully as well as a foreigner.

DR BANNERJI: Will you unbutton your shirt?

HOBSON hesitates and then unbuttons.

94

HOBSON: No hanky-panky now.

DR BANNERJI: (*Ignoring his remark and examining.*) Aye. It just confirms ma first opinion. You've had a breakdown this morning?

HOBSON: You might say so.

DR BANNERJI: Melancholic? Depressed?

DR BANNERJI does some other tests. She takes out an electric blood pressure machine and takes HOBSON's pressure.

HOBSON: (*Buttoning his shirt.*) Question was whether the razor would beat me or I'd beat the razor. I won that time. The razor's in the back garden, but I'll never dare to try shaving myself again.

DR BANNERJI: And do you seriously require me to tell you the cause, Mr Hobson?

HOBSON: That's why I called you over.

DR BANNERJI: Chronic alcoholism, if you know what that means.

HOBSON: Yes.

DR BANNERJI: A serious case.

HOBSON: I know it's serious. Why do you think you're here? It isn't to tell me something I already know. It's to cure me.

DR BANNERJI: I'll write you a prescription.

She produces a pad from her bag and starts to write.

HOBSON: Stop that!

DR BANNERJI: Pardon?

HOBSON: I won't take it. None of your pharmaceutical muck for me. I'm particular about what I put into my stomach.

DR BANNERJI: You are are ye? You reek of tobacco and booze, the place stinks of unhealthy fried food and you say you're particular – eh? Mr Hobson, if you don't mend your manners, I'll section you to a psychiatric hospital. Are you aware that you've drunk yourself within six months of the grave? You'd a warning this morning that any sane man would listen to and you're going to listen to it sir.

HOBSON: By taking your pills?

DR BANNERJI: Precisely. You will take these pills, Mr Hobson and you will practise total abstinence for the future.

HOBSON: You expect me to give up my reasonable refreshment!

DR BANNERJI: Give up the booze. I forbid alcohol absolutely. Would you like me to recommend a good self- help group like Alcoholics Anonymous?

HOBSON is furious.

HOBSON: No, I would not. I've enjoyed the drink ever since I came to this country thirty-five years ago. If I'm to be beaten by beer I'll die fighting and I won't stop drinking for the sake of lengthening out my unalcoholic days. Life's got to be worth living before I'll live it.

DR BANNERJI: (*Getting up.*) If that's the way you feel, my services are of no use to you.

HOBSON: They're not. Although you've been a tonic to me. When I got up I never thought to see the The Nelson again but I'm ready for my early morning draught this minute.

DR BANNERJI earnestly approaches HOBSON.

DR BANNERJI: Man will you no be warned? You pig-headed animal, alcohol is poison to you, deadly, virulent with a system in the state yours is.

HOBSON turns away.

I have na finished with you yet.

HOBSON: I thought you had.

DR BANNERJI: Do you know that you're defying me?
You'll die fighting, will you? Aye, it's a high-sounding
sentiment ma man, but you'll no dare it do you hear?
Ye'll no slip from me now. I've got ma grip on you.
You'll die sober, and you'll live the longest time you can
before ye die. Have you a wife Mr Hobson?

HOBSON points upward.

In bed?

HOBSON: Higher than that.

DR BANNERJI: It's a pity. Men like you need wives.
You're all the same. My Da was like you. Hopeless at
looking after himself.

HOBSON: I'm not so partial to women.

DR BANNERJI: To men like you – women are a necessity
sir. Have you no female relative that can manage ye?

HOBSON: Manage?

DR BANNERJI: Keep a close eye on ye?

HOBSON: I've got three daughters, Dr Bannerji and they
tried to keep their eyes on me.

DR BANNERJI: Well, where are they?

HOBSON: I'm well shot of them. They're married and out
of here.

DR BANNERJI: You probably drove them to it.

HOBSON: They got above themselves. Durga especially.

DR BANNERJI: Durga? Then I'll tell ye what ye'll do, Mr Hobson. You will get Durga back at any price. At all costs to your pride. As your doctor I order ye to get Durga back. I prescribe her and damn you, man, are you going to defy me again?

HOBSON: I tell you, I won't have it.

DR BANNERJI: You'll have to have it. You're an idiot. A big lump of obstinacy but I've take a shine to you and I won't let ye kill yourself.

HOBSON: I've escaped from the imprisonment of women once and…

DR BANNERJI: And a pretty mess you made of your freedom. I know Durga so I'll just pop in to see her and have a word with her myself. I've already gone beyond the sparing of a bit of trouble over you.

HOBSON: Waste of time.

DR BANNERJI: I'll cure you, Mr Hobson.

HOBSON: She won't come back.

DR BANNERJI: Oh. Now that's a possibility. If she's a sensible woman I concur with your opinion she'll no come back. But unfortunately for us, women are soft-hearted race and she'll maybe take pity on you after all.

HOBSON: I want no pity.

DR BANNERJI: If she's the woman that I take her for you'll get no pity. You'll get discipline.

HOBSON rises and tries to speak.

Don't interrupt me, sir, I'm talking.

HOBSON: I've noticed.

HOBSON sits.

DR BANNERJI: You asked me for a cure and Durga's the name of the cure you need. Durga, sir, do you hear? Durga!

Enter DURGA.

DURGA: What about me?

DR BANNERJI is taken aback.

DR BANNERJI: Ah – there you are…

HOBSON: What are you doing under my roof?

DURGA: I came because I was asked to.

HOBSON: Who asked you?

DURGA: Tubby bhai.

HOBSON: (*Rising.*) I'll sack him this minute.

DR BANNERJI: (*Pushing HOBSON down.*) Sit down Mr Hobson.

DURGA: He said you were dangerously ill.

DR BANNERJI: He is. Tell me Durga, could you come and live here again?

DURGA: I'm married.

DR BANNERJI: I know that Mrs Mossop –

DURGA: *Ms* Hobson actually.

DR BANNERJI: So sorry – Ms Hobson. Your father's drinking himself to death.

HOBSON: Look here Doctor, what's passed between you and me isn't for everybody's ears.

DR BANNERJI: I judge your daughter can face the facts.

DURGA: Go on. I'd like to hear it all.

HOBSON: Just nasty-minded curiosity.

DR BANNERJI: I don't agree with you Mr Hobson. If Ms Hobson is to sacrifice her own home to come to you, she's every right to know the reason why.

HOBSON: Sacrifice! If you saw her 'home' – it's a shed in some toff's back garden.

DR BANNERJI: I have seen her place of work and I've had the privilege of having my suits made by her good husband.

DOCTOR shows off her jacket.

HOBSON is outraged.

DURGA: I'm waiting Doctor.

DR BANNERJI: I've a constitutional objection to seeing patients slip through ma fingers when it's avoidable, Ms Hobson and I'll do ma best for you father but ma medicine willna do him any good without your medicine to back me up. He needs a tight reign on him all the time.

DURGA: I haven't been around much since I married.

DR BANNERJI: You must come and live here – on the broad grounds of humanity, you'll save a life if you'll come –

DURGA: I might.

DR BANNERJI: Nay, but will ye?

DURGA: You've given your opinion, the rest is up to me.

HOBSON: That's right, Durga. (*To DOCTOR.*) That's what you get for interfering with people's private affairs. So now you can go, with your tail between your legs, Dr Bannerji.

HOBSON glances curiously at the doctor's jacket again.

DR BANNERJI: On the contrary, I am going Mr Hobson with the profound conviction that I leave you in excellent hands. One prescription is on the table. The other two are total abstinence and (*To DURGA.*) you.

DURGA: (*Nodding amiably.*) Thank you.

DR BANNERJI: Goodbye.

Exit DOCTOR.

DURGA picks up the prescription and follows to the door.

DURGA: Tubby bhai!

She stands by the door, flicks open her mobile phone and dials a number.

TUBBY enters.

Tubby bhai, could you pick up this prescription from the chemists?

DURGA hands him some money.

TUBBY: Yes Memsahib – I mean Mrs Mossop.

DURGA: Durga.

TUBBY nods and exits.

DURGA talks on the phone.

Ali, it's urgent. Can you get here as soon as you can? (*She looks at HOBSON.*) Yes, I'm afraid so.

DURGA snaps shut her phone and looks around the room with distaste. She starts to tidy away the many bottles littered over the floor, emptying ashtrays into the bin etc.

HOBSON: You know I can't be an abstainer. A man of my habits. At my time of life.

DURGA: You can if I come here to make you.

HOBSON: Are you coming?

DURGA: I don't know. I need to talk it over with my husband.

HOBSON: Talk it over with Ali Mossop! Durga, I'd thought better of you. Making an excuse like that to me. If you want to come you'll come.

DURGA: Actually, I don't want to Baba. It's hardly going to be a holiday trying to keep you in health and under control. But if Ali tells me it's my duty, I shall come.

HOBSON: Oh come on. You don't need to pretend with me. Everyone knows Ali doesn't wear the trousers in your house.

DURGA: My husband's my husband, Baba, whatever else he is. And my home's my home and I'll remember what you said of it just now to Dr Bannerji. I managed to escape this house and I'm not mad keen on coming back to this place.

HOBSON: Okay, let's talk straight then. You're coming here wasn't my idea – it was the Doctor's. But now you're here, I want you here. It's been my daughters' hobby to hassle me. Now you'll come and look after me.

DURGA: All of us?

HOBSON: No. Not all of you. You're the eldest.

DURGA: There's another man who I have to think of.

HOBSON: Aren't I your father?

SUNITA enters. She is rather elaborately dressed for so early in the day, with hair and beautifully manicured nails. She looks haughty.

DURGA: And I'm not your only daughter.

SUNITA: You been here long Durga?

DURGA: A while.

SUNITA: I suppose, having your own business means you have to get up at the crack of dawn. Some of us are luckier. Baba, you're looking great. You've got some colour in your cheeks.

HOBSON: I'm very ill.

DURGA: The doctor says one of us must come and live here to look after him.

SUNITA: Well I can't. We're in the middle of redoing our kitchen.

HOBSON: Suni!

SUNITA: What about Durga? She's the oldest.

HOBSON: You little…

RUBY enters and rushes to HOBSON.

RUBY: Baba, you're ill!

HOBSON: Ruby! My baby! At last, I find a daughter who cares about me.

RUBY: Of course I care. (*Embracing him.*)

HOBSON: You will live with me, Ruby, won't you?

RUBY: Actually, that might be a bit tricky. (*She moves away from HOBSON.*)

DURGA: One of us needs to come and be with him.

RUBY: I've got some good news… I'm expecting.

DURGA: Congratulations. (*She turns to HOBSON.*) Don't you think you ought to have a wash and put some clothes on before Ali comes? You're a bit whiffy.

HOBSON: Get dressed for Ali Mossop? There's something wrong with your sense of proportion, my girl.

RUBY: You're always pretending to people about your husband but you needn't keep it up with us. We know Ali here.

DURGA: Either I can go home or you can go and tidy yourself up for Ali. You'll treat him with respect.

SUNITA: You were probably about to get dressed anyway.

HOBSON: (*Rising.*) Of course I was. I'm going to have a shower and put some clothes on. But understand me Durga, it's not for the sake of Ali Mossop. It's because I want to. Now get out of here – all of you and give me some privacy.

SUNITA, RUBY and DURGA all exit into the shop.

DURGA: Now then, which of us is it to be?

RUBY: No use looking at me like that, Durga, I've told you, I'm expecting.

DURGA: I don't see that rules you out. Any one of us could fall pregnant. We've all got healthy sex lives now and I bet Suni and Steve are at it like rabbits.

SUNITA: Durga!

DURGA: Been married a year now and Ali can't keep his hands off me. It's a wonder he's got the energy to run a successful business as well.

RUBY and SUNITA look astonished.

SUNITA: Well, I'm not going to break my home up, and that's that.

RUBY: My child comes first.

DURGA: I see. You've got a house of furniture and you've got a baby coming, so Baba can drink himself to death for all you care.

SUNITA: That's not fair. I'd come if there were no-one else. It's your duty Durga.

RUBY: I would have thought it'd be a pleasure to live here after a year or two in a shed.

DURGA: Actually, we've got two sheds now and I've had thirty years of the pleasure of living with Baba, thanks.

SUNITA: So you won't do it?

DURGA: It isn't for me to say. I need to talk to my husband.

RUBY: Oh give it a rest. If me and Sunita don't need to ask ours, I'm sure you don't need to ask yours. Ali's like a mouse. He'll do exactly what you tell him to do.

DURGA: Maybe Ali's come on since you saw him Ruby. It's getting on a while.

ALI MOSSOP walks in, he nods at the women. He looks wonderful, sexy, well groomed and dressed in a beautifully cut suit. He looks full of confidence.

SUNITA and RUBY are taken aback and stare at him.

DURGA: Ah there he is. I'll go and talk to him.

ALI climbs a ladder to look at the stock.

DURGA goes to talk to him.

SUNITA and RUBY look around with distaste.

SUNITA: I'm not coming back here.

RUBY: Me neither.

SUNITA: It's so poky in here. Can't believe the size of that kitchen.

RUBY: Don't know how we put up with it all those years.

SUNITA: I've got a new Pogen Pohl being fitted.

RUBY: We have a separate breakfast room.

SUNITA: Only Durga could do this.

RUBY: Yes, but we've got to be careful Suni. She mustn't have her own way.

SUNITA: But it's what we want isn't it?

RUBY: Yes, but when she's alone with him and we're not…

SUNITA: What?

RUBY: Suppose he gets worse and they're here, Durga and Ali and you and I – out of sight and out of mind. Know what I mean?

SUNITA: He might leave them his money? We must get him to make a will at once. Steve can draw it up.

RUBY: That's it. And let's not leave Durga too long with Ali. She's probably telling him what to say and then she'll pretend he thought of it himself.

She opens the door and looks up surprised.

Ali. What are you doing up the ladder?

ALI: (*Off.*) Looking over the stock.

RUBY: It's Baba's stock, not yours.

ALI: (*Off.*) Yes, but if I'm coming into a thing I like to know what I'm coming to.

SUNITA: That's never Ali Mossop.

RUBY: (*Still by the door.*) Are you coming into this?

ALI enters.

DURGA follows him. He is not aggressive but he is prosperous and has self-confidence. He is dressed casually but smart, well groomed and handsome. He still wears a tape measure around his neck.

ALI: That's the proposal isn't it?

RUBY: I didn't know it was.

ALI: Now then babe, go and bring your Baba down and tell him to hurry up please. We're busy today…unlike this place.

DURGA exits.

SUNITA: What're you going on about? This is a good business.

ALI: You try and sell it and you'll see. Stock and good will would fetch very little.

RUBY: Crap.

ALI: It's not a thriving business like in our time Ruby.

SUNITA: What? You mean Baba isn't rich?

ALI: If you hadn't married a lawyer, you'd know what they think of your Baba today in the business.

RUBY: The value of Baba's shop is nothing to do with you.

ALI: If Durga and me are coming here…

RUBY: You're coming to look after Baba.

ALI: Durga can do that with one arm tied around her back. I'll look after the business.

SUNITA: You'll do what's arranged for you.

ALI: I'll do the arranging Sunita. If we come here, we come here on my terms.

RUBY: They'll be fair terms.

ALI: I'll make sure they're fair to me and Durga.

SUNITA: Do you know who you're talking to?

ALI: Yep. My wife's younger sisters. Things have moved on a bit since you used to order me around the shop, haven't they, Suni?

SUNITA: Yes. I'm *Mrs* Stephen Prosser now.

ALI: So you are. And I'm *Mr* Ali Mossop. Time changes everything – doesn't it?

RUBY: Some people change beyond recognition.

ALI: That's a matter of opinion. I know Durga and me gave both of you a big leg up when we arranged your marriages but we aren't grudging your successes now.

Enter HOBSON and DURGA.

ALI: Good morning Baba. I'm sorry to hear you're not so well.

HOBSON: I'm a different man, Ali.

He sits on a chair.

ALI: There was a lot of room for improvement.

HOBSON: What! (*He starts up.*)

DURGA: Sit down Baba.

ALI: (*Looks at his watch.*) Let's get on with it. You've kept me waiting and my time's valuable. I'm very busy at the shed.

HOBSON: Is your shed more important than my life?

ALI: I'm worried about your life because it worries Durga but I'm not so worried that I'll see my business suffer for the sake of you.

HOBSON: This isn't what I've a right to expect from you Ali.

ALI: You've no right to expect I care whether you sink or swim.

DURGA: Ali.

ALI: What? You told me to be firm.

SUNITA: Do we have to stand here and watch Durga and Ali abuse Baba when he's ill?

ALI: No need to stay.

HOBSON: That's true.

RUBY: Baba! Whose side are you on? We're your own flesh and blood!

HOBSON: That doesn't come too well from you, my girl. Neither of you would leave your homes to come to care for me. You're not for me, so you're against me.

SUNITA: We're not against you. We want to stay and see that Ali is fair with you.

HOBSON: Now I'm incapable of looking after myself am I? I have to be protected by you girls in case I'm swindled by whom? By Ali Mossop! I may be sick but I've enough fight left in me for a dozen men like him and if you're thinking that I'm not man enough, you can go and think it somewhere else than in my house.

RUBY: But Baba, dear Baba...

HOBSON: I'm not so dear to you if you'd think twice about coming here to look after me. All that complaining! A proper daughter would have jumped – yes, skipped like a calf by the cedars of Lebanon – at the thought of being helpful to her Baba.

SUNITA: Did Durga skip?

HOBSON: She's a bit old for skipping.

DURGA: (*Dry.*) Thank you.

HOBSON: But she's coming round to the thought of living here and that's more than you're doing Suni isn't it? Eh? Are you willing to come?

SUNITA: (*Sullenly.*) No.

HOBSON: Or you, Ruby?

RUBY: It's my baby, Baba I…

HOBSON: Never mind the excuses. Are you coming or
 not?

RUBY: No.

HOBSON: Then leave and let me talk with those that are.

SUNITA: You want us to go?

HOBSON: You've got a home to go to haven't you?

SUNITA: Oh Baba!

HOBSON: Open the door for them Ali.

ALI hesitates

Please.

ALI rises and opens the door.

SUNITA and RUBY stare in silent anger.

SUNITA: Ruby!

RUBY: Well, I don't know.

DURGA: We'll be glad to see you here for Sunday lunch if
 you'll condescend to visit us sometimes.

RUBY and SUNITA exit in a huff.

ALI returns to his chair.

HOBSON: Now *beta*, I'll tell you what I'll do. They've got
 stiff necks with pride and the difference between you two
 and them is well worth noting. There's times for holding
 back and times for letting loose and being generous.
 Now if you come back to live here you can have the

back bedroom for your own and the use of this room and the lounge shared with me. Durga can keep house and if she's got any time to spare, she can give us a hand in the shop. I'll give you a job. You can have your old bench in the basement and I'll pay you your old wage and you and me'll split the housekeeping. Can't say fairer than that eh? A rent-free roof over your head and paying half the keep of your wife.

ALI: (*Rises.*) Let's go home.

DURGA: I think I'll have to.

HOBSON: Why?

ALI: It may be news to you but I've a business round in Oldfield Street and I'm neglecting it by wasting my time here.

HOBSON: Wasting time? Durga, what's the matter with Ali? I've made him a business proposal.

ALI has walked to the door.

DURGA: He's got his own shop to look after.

HOBSON: (*Incredulous.*) A man who's offered a job at Hobson's doesn't want to worry with a shop of his own in a wretched shed in Oldfield Road.

ALI: Shall I tell him Durga or shall we just go?

HOBSON: Go! I don't want to keep a man who…

DURGA: If he goes, I go with him Baba.

ALI: We've been a year in the shed and do you know what we've done? We paid off Dr Bannerji the money she lent us for our start, we're up to date with our rent and we've made some profit on top of that.

HOBSON: Dr Bannerji… I might have known…

ALI: We've taken your customers away from you. They come to us now. That shop's a shed and as you say, it's wretched but they still come to us – in droves – and they don't come to you. Your business has gone downhill and now all you sell are a few ties and shirts. You've got no business and soon you'll be bankrupt. Me and Durga have it all and now you're on bended knees to her to come and live with you and all you can think of is to offer me my old job, with the same lousy wages. I'm the owner of a business that's starving yours to death.

HOBSON: But…but…you're Ali Mossop, you're my old tailor…my worker.

ALI: I was but I've moved on a bit since then. Your daughter married me and educated me. And now I'll tell you what I'll do and it'll be a favour I'm doing for you. We'll close our shed…

HOBSON: Can't be doing too well then after all!

ALI: I am doing well but I'll do better here. I'll transfer to this address and I'll be generous to you. I'll take you into partnership and give you your half share on the condition you are a sleeping partner and you don't try to interfere with my work.

HOBSON: A partner! You – here –

ALI: 'Rindi Sindi Fashion House' is the name I'll give this shop.

DURGA: Hold on. Ali, I don't agree.

HOBSON: Oh, so you have piped up at last. I began to think you'd both lost your senses.

DURGA: I don't think it should be 'Rindi Sindi'.

ALI: I think it should.

HOBSON: Just a minute. Let me get this right. I'm to be given half-share in my own business on condition I take no part in running it. And it's to be called…'Rindi Sindi'?

ALI: That's it.

HOBSON: Of all the impudent, downright low…

DURGA: It's alright Baba.

HOBSON: But did you hear what he's talking about?

DURGA: Yes. That's settled. It's only the name we're arguing about. (*To ALI.*) I won't have 'Rindi Sindi Fashion House', Ali.

HOBSON: You tell him my girl.

DURGA: I think Eshana Boutique is best.

HOBSON: What?

DURGA: No.

ALI: Rindi Sindi Fashion House or it's the shed for us Durga.

DURGA: Okay. Rindi Sindi.

HOBSON: But…

ALI looks around the place.

ALI: I'll make some alterations in the shop.

ALI picks up a battered old cane chair.

HOBSON: Alterations in my shop!

ALI: In mine. Look at this chair. How can you expect wealthy clients to sit on a chair like that? We've only got a shed but our clients sit on silk cushions, drink herbal teas and nibble on pistachios.

HOBSON: Silk! Herbal teas? That's just pampering people!

ALI: Silk for a shed and soft leather for this shop. People like to feel special, to be pampered when they're spending money for high quality clothing. Pampering pays. I'll get some oak floors laid and throw a few rugs about too… and we'll employ some models so that our clients can view the clothes they're buying. Your sisters'd do the job wouldn't they?

DURGA: They'd be made up.

HOBSON: Models? Parading around like tarts in here?

ALI: All the best fashion houses do it these days.

HOBSON: Young man, this is Salford, not Harvey Nichols.

ALI: Not yet, but it's going to be.

HOBSON: (*Appealing to heaven.*) Bhagawan?

ALI: It's no farther from our shed to Harvey Nichols than it is from Oldfield Street to here. I've done one big jump in a year and if I wait a bit I'll do the other. Babe, I think your Baba could do with a bit of fresh air after this. It's probably come a bit sudden. Why don't you walk with him to Steve Prosser's office and get Steve to draw up the deed of partnership?

HOBSON looks pathetically first at DURGA, then at ALI, rising obediently.

Exit HOBSON.

ALI: He looked crushed. Maybe I was too hard on him.

DURGA: Don't worry.

ALI: Those things I said! And they sounded as if I meant them too.

DURGA: Didn't you?

HOBSON'S CHOICE: ACT FOUR

ALI: Did I? Yes…I suppose I did. You told me to be strong and use the power that's come to me through you, but he's my old boss and…

DURGA: And you're the new one.

ALI: Owner of Hobson's. It's amazing. Did I sound confident?

DURGA: You did all right.

ALI: But I wasn't half as certain as I sounded. I couldn't believe the words that were coming out of my own mouth and when it came to challenging you about the name…I got carried away or I'd never have dared challenge you.

DURGA: Don't spoil it Ali. (*She approaches him.*) You're the man I've made you and I'm proud.

ALI: Your pride's not in the same street as the pride I have in you. And that reminds me. I've got another job to do.

DURGA: What job?

ALI: Oh – about improvements.

DURGA: You're not going to do anything without consulting me.

ALI: I'll do this.

ALI takes her hand.

DURGA: What are you doing? You leave my wedding ring alone.

DURGA wrenches her hand free.

ALI: You've worn brass long enough.

DURGA: I'll wear that ring forever.

ALI: I wanted to get you a proper one.

DURGA: I'm not stopping you. I'll wear the gold for show but that brass stays where you put it Ali and if we get too rich and proud we'll just sit down together and take a long look at it so that we never forget the truth about ourselves.

They kiss and kiss and kiss…

Enter HOBSON wearing his coat. He watches the couple and smiles.

Postscript.

SUNITA, RUBY, STEVE, ROBBIE, PINKY, DR BANNERJI do a turn on the stage to Hindi music, Bollywood catwalk style, displaying ALI MOSSOP's latest creations.

The End.